GUANACASTE

COSTA RICA **REGIONAL GUIDES**

María Montero and Luciano Capelli

AN OJALÁ EDICIONES & ZONA TROPICAL PUBLICATION
from
COMSTOCK PUBLISHING ASSOCIATES
an imprint of
CORNELL UNIVERSITY PRESS
ITHACA AND LONDON

First published 2019 by Cornell University Press

Printed in China

Library of Congress Cataloging-in-Publication Data

Names: Montero, Maria (Travel writer), author. | Capelli, Luciano, author.
Title: Guanacaste / Maria Montero and Luciano Capelli.
Description: Ithaca : Comstock Publishing Associates, an imprint of Cornell
University Press, 2019. | Series: Costa Rica regional guides |
"An Ojalá Ediciones & Zona Tropical publication." | Includes index.
Identifiers: LCCN 2019008046 | ISBN 9781501739279 (pbk. ; alk. paper)
Subjects: LCSH: Guanacaste (Costa Rica)—Description and travel. | Ecology—Costa
Rica—Guanacaste. | Natural history—Costa Rica—Guanacaste.
Classification: LCC F1549.G9 M73 2019 | DDC 972.86/6—dc23
LC record available at https://lccn.loc.gov/2019008046

Front cover photo: Luciano Capelli
Back cover photo: Pepe Manzanilla

The world knows Costa Rica as a peaceful and environmentally conscious country that continues to attract several million tourists a year, yet this image may obscure a social and biological legacy that very few visitors get to know.

We hope that the six books in this collection will reveal a reality beyond the apparent one. These are meant to pique the curiosity of travelers through stories about nature, geology, history, and culture, all of which help explain Costa Rica as it exists today.

Each title is dedicated to those who fought, and continue to fight, with grace and wisdom, for a natural world that lies protected, in a state of balance, and accessible to all, in other words, one that is closer to the ideal we seek to make real.

DEDICATION

DANIEL JANZEN AND WINNIE HALLWACHS

Daniel Janzen and Winnie Hallwachs have contributed more to the transformation of Guanacaste than any other person. In the 1980s, when Costa Rica was en route to becoming the country with the highest rate of deforestation in the Americas, they abandoned the comfort of their academic careers to defend the subjects of their research from extinction.

Daniel and Winnie dreamed of turning Santa Rosa, a cattle hacienda ravaged by fires for four centuries, into a protected area that would last "forever." Although their plan seemed quixotic at first, their enthusiasm would end up winning over the sceptics.

In addition to acquiring several millions of dollars to buy land, they developed the scientific methodologies and guidelines that would be relied on to regenerate the forests, in the process inspiring a group of government officials who would devote themselves body and soul to this task.

What thirty years ago were pastures hardened by roaming cattle, today are beautiful secondary forests, more alive each season with the sounds of wildlife. The jaguars, tapirs, and peccaries have returned to the region, crossing from the coast to the tops of the volcanoes, tracing paths that will give nature a second chance.

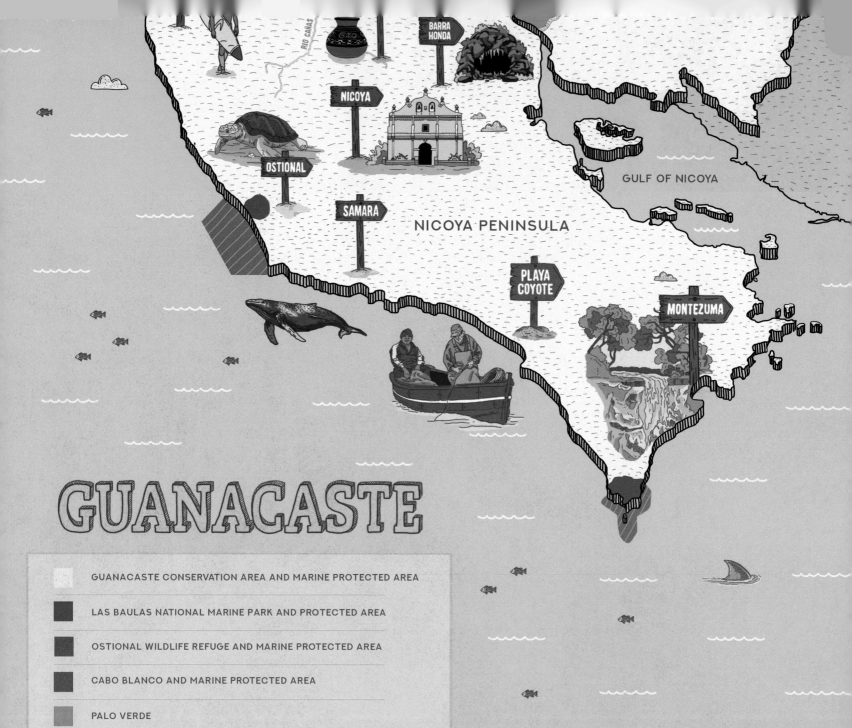

GUANACASTE

RÍO CAÑAS

BARRA HONDA

NICOYA

OSTIONAL

SAMARA

NICOYA PENINSULA

GULF OF NICOYA

PLAYA COYOTE

MONTEZUMA

Legend:

- GUANACASTE CONSERVATION AREA AND MARINE PROTECTED AREA
- LAS BAULAS NATIONAL MARINE PARK AND PROTECTED AREA
- OSTIONAL WILDLIFE REFUGE AND MARINE PROTECTED AREA
- CABO BLANCO AND MARINE PROTECTED AREA
- PALO VERDE
- RIVERS

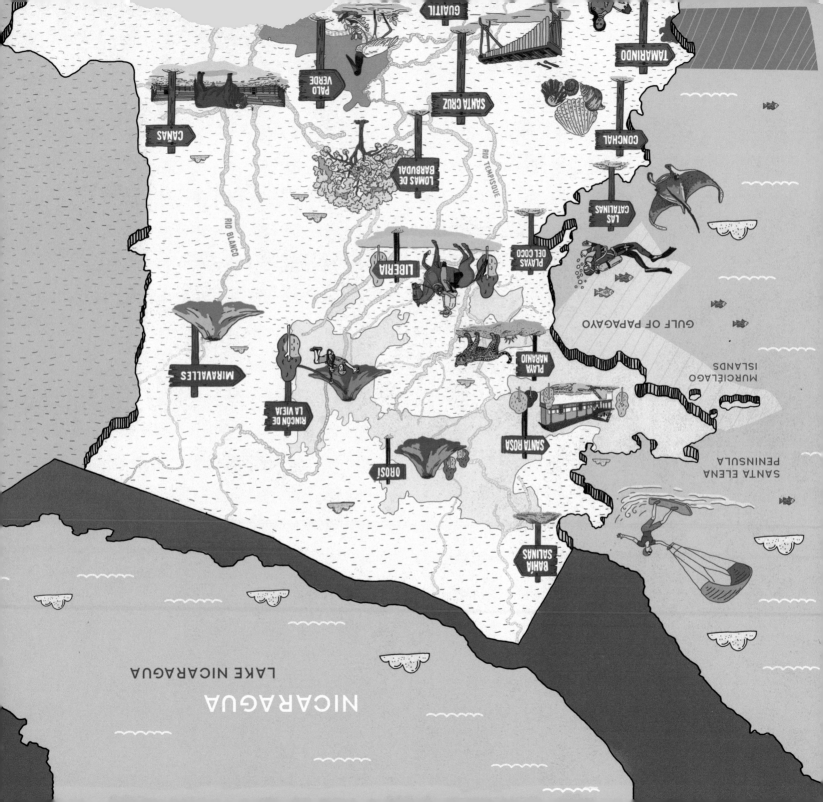

GUANACASTE

COSTA RICA REGIONAL GUIDES

CONTENTS

THE LAND
OF SUMMER

P 1

THE FOREST
REGROWS

P 39

OF PAMPAS
AND SAVANNAHS

P 83

INDEX

P 115

CREDITS

P 117

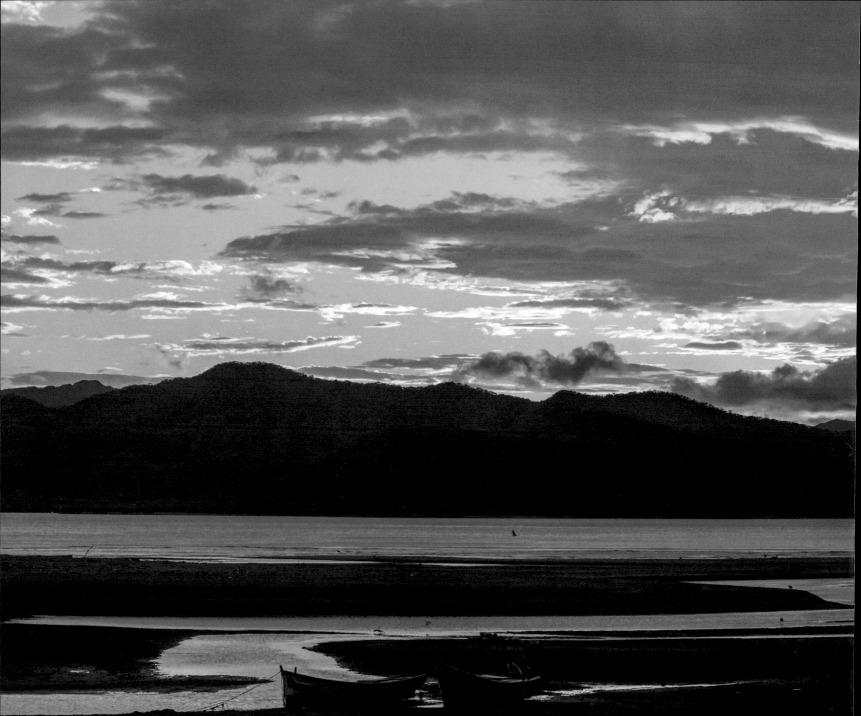

THE LAND OF
SUMMER

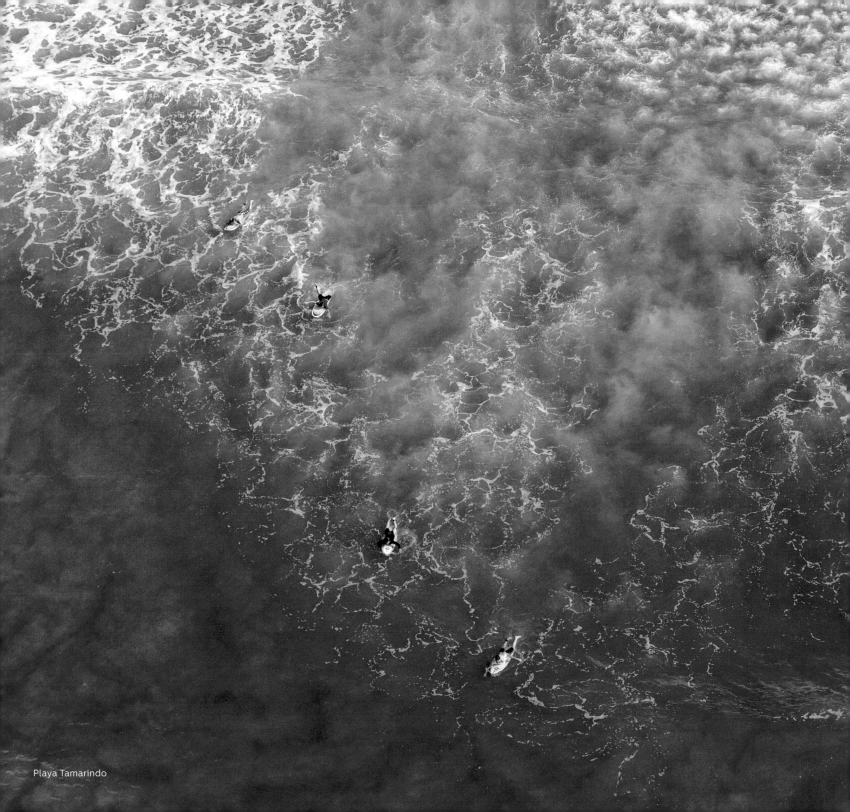

Playa Tamarindo

More than any other province in Costa Rica, Guanacaste is the embodiment of all things summery. Nearly constant sunshine blankets its 3.9 million square miles (10 million km²) and every aspect of life seems to bear the imprint of the heat, from the trees and orchids to the macaws and butterflies, from the small agricultural villages nestled within rolling hills to the luxurious shoreline hotels.

An incredible repertoire of tropical biodiversity can be found in the beaches, forests, mountains, islands, rivers, and caverns of this region, and such biodiversity, celebrated in the myths of ancient native cultures, today appears in the folktales of local peoples.

While Guanacaste is not the largest province in the country, you might easily think that it is. The overwhelming plains and arid extensions of dry forest, which distinguish its geography, especially in the north, are not replicated anywhere else in Costa Rica and are unlikely to be found in the Mesoamerican region as a whole.

Its stately haciendas, born of the latifundios and giant cattle ranches, are universes in slow motion, and represent a way of life difficult to understand for those not raised there; nor does any other region of the country experience such scorching temperatures, a fact that has turned this peninsula into one of the most important beach destinations in the region.

Its landscapes are also hauntingly beautiful in the rainy season, when the province becomes green anew and the cool shimmer of the jungle is projected onto the sea.

The first rain showers in May release the colors of the dry forest, and millions of insects, which were previously larvae, buzz in the humid air, which is filled with the sound of singing birds and croaking frogs. Thousands of fireflies appear at night, announcing with their brightness the start of a new cycle of life.

The arrival of millions of sea turtles, who come ashore to lay their eggs, transfigures the towns on the Pacific, especially historical nesting sites such as Ostional, Playa Grande, and Corozalito.

The beginning of the dry season, which comes just four months after the rain showers, transforms the colors of the vast grasslands. Rosy and pink trumpet trees (*Tabebuia rosea* and *Tecoma impetiginosa* respectively), pink shower trees (*Cassia grandis*), and *cortez amarillo* trees (*Tabebuia ochracea*) drop their leaves and begin their reproductive cycles, all the while cloaked in bushy bouquets that, as they fall, paint the cracked earth with pinks, purples, yellows, and oranges—they take advantage of the strong summer winds to disperse their seeds and colonize new areas.

Near the coast and in the lowlands, where the heat is even more relentless—and its effects more apparent—"streams" of leaf litter sweep the thirsty riverbeds and the skeletons of fish accumulate above their dry, buried eggs. Wherever there are pools left, monkeys, deer, agoutis, and hundreds of other animals arrive in search of fresh water.

In this, the dry season, the trade winds from the Caribbean intensify. As soon as they cross Lake Nicaragua toward Bahía Salinas and the Gulf of Papagayo, they dive violently into the open ocean, causing an exchange between surface waters and deep waters and thus uncovering new sources of food for birds and marine fauna.

As the cold waters from down deep reach the surface of the ocean, there also arrives a parade of at least 19 species

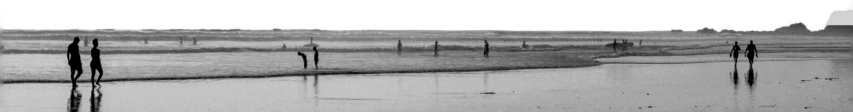

of whale and dolphin, a spectacle that follows after the disturbance caused by the wind and its powerful, invisible currents in the depths of the Pacific Ocean, off the coasts of Guanacaste.

Also typical of this season is the appearance of a species whose two feet, clad in sandals, kick up dust along the trails that lead to the ocean. In these months, without a drop of rain and temperatures during the day that do not dip below 86 °F (30 °C), Guanacaste is, paradoxically, a scene of flourishing biological transformations and bears witness to tourists from around the world seemingly intent on colonizing the land anew.

Since Pre-Columbian times, adventurers of all kinds have passed through the province, but the formula of sun +beach+landscape has most contributed to the evolution of modern-day migrations, a potpourri including anonymous millionaires, renowned movie stars, biologists, surf lovers, families from the capital, partiers, budget backpackers, and everyone else you might imagine.

Along 185 miles (300 km) of coastline, from the border with Nicaragua, at Bahía Salinas, to the rocky shelf of Cabo Blanco, at the southernmost point of the Nicoya Peninsula, and passing through the most ancient terrain in the country, on the Santa Elena Peninsula, this region boasts more than 120 beaches! Each beach seemingly offers something unique, whether a curtain of virgin forest that grows down to the water's edge, turquoise waters, white sand, waves that are ideal for surfing, utter solitude, or miles of shell strewn shores.

As you follow along this beach route, you will come upon varying landscapes, including bays, gulfs, points, cliffs, estuaries, and mangroves, until the coast finally reaches its terminus point and begins to bend north again and you enter the waters of the Gulf of Nicoya.

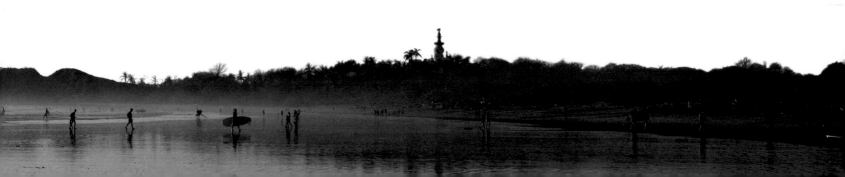

Not far from the mainland, paradisiacal islands in the Murciélago Islands archipelago and tiny uninhabited gardens that compose the Islas Catalina reveal the geological splendors that lie beneath the surface of the ocean.

At the end of the 19th century, fishing villages, scattered and forgotten along the extensive coastline, began receiving Costa Rican tourists, some from distant regions in the country, and there appeared in the popular imagination of *ticos* a postcard view of their own country, one of white sand and crystal waters.

Social transformations in Costa Rica linked to the economy and new patterns of work lead to a novel notion, the concept of *free time*. And the beaches became the place where many *ticos* chose to indulge this new idea.

With the onset of the dry season and warmer temperatures, wealthy families from Liberia and San José would arrive in oxcarts and on horseback at Playas del Coco, and traverse the sand with their pale feet, making this, over the years, one of the oldest and most popular beach destinations for many Costa Ricans. On starry nights, beachgoers—dreaming of a permanent stay here—would find themselves, all of a sudden, in the midst of marimba music and *bailongos* (dance parties), and to this day a bohemian vibe seems to dominate the beaches in this area.

It was a slow, often imperceptible, process that turned beaches like Conchal, Avellanas, Sámara, and Brasilito into the vacation dream spots for families making temporary migrations in search of sun, waves, saltwater, and *cerveza*.

While scenic beauty was to be found from the beginning, there was scant infrastructure to accommodate visitors. There were hotels, but they were few in number. And until the second half of the 20th century, there were few places to stay beyond rustic wooden shacks tended to by fishermen, single cabins for multi-family use, or low budget rooms in buildings already inhabited by locals.

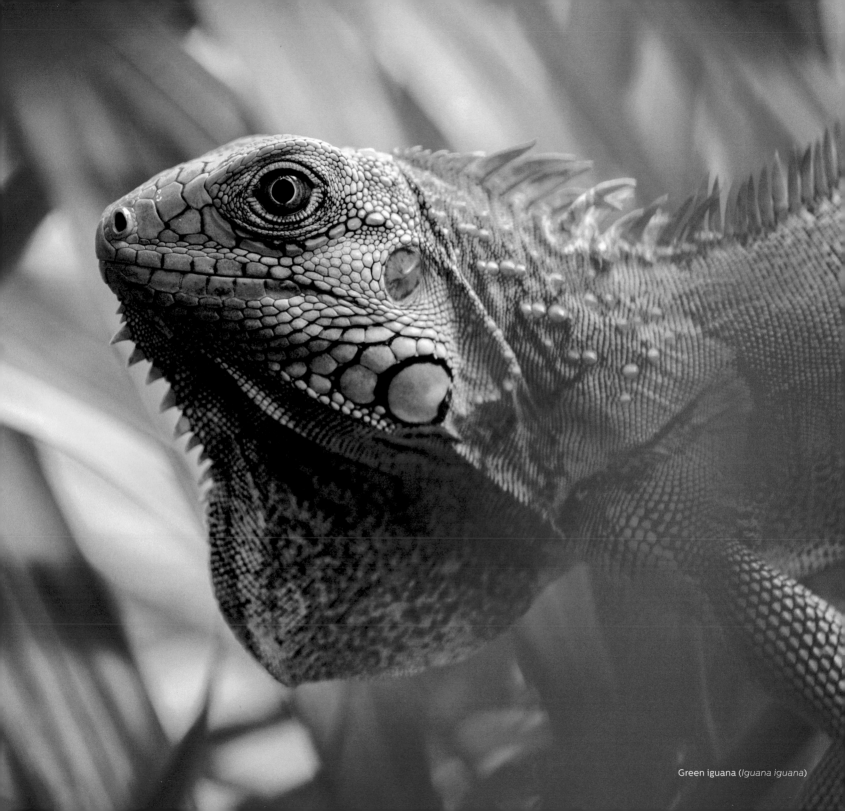

Green iguana (*Iguana iguana*)

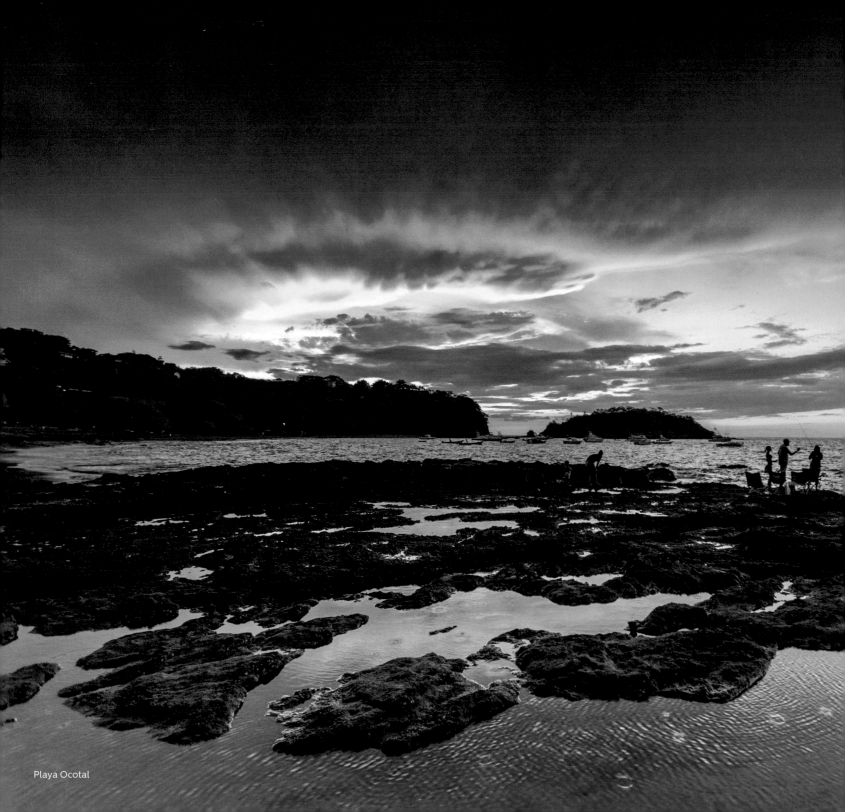

Playa Ocotal

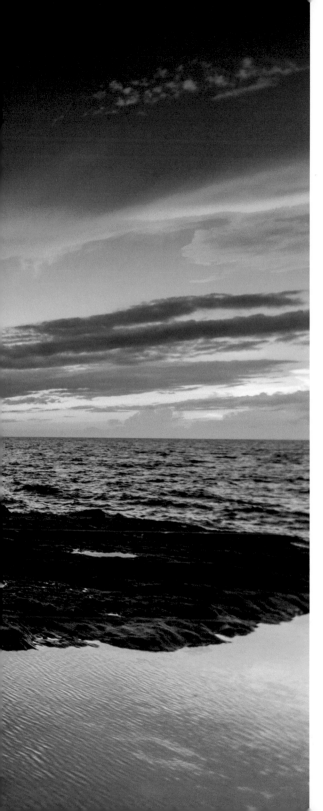

The allure of ocean sunsets was enough for many people, and the lack of fancy rooms or other amenities was often part of the romantic charm of the region. But over time, the development of new infrastructure, the rise of surfing as a sport linked to nature, and, later, the marketing campaigns of a "green and peaceful" Costa Rica, and the consequent boom in real estate, placed Guanacaste on the international travel map.

The completion of the Pan-American Highway in 1959 and the transformation of the Liberia airport into an international terminal in 1995 made it easier to reach Guanacaste and contributed to the tourism boom here, with the result that today hundreds of thousands of visitors arrive each year.

Some of the most staggering changes in the province fall within this 40-year period and represent the culmination of centuries of human transit through a province made by and for travel, beyond its beaches, but never very far from them.

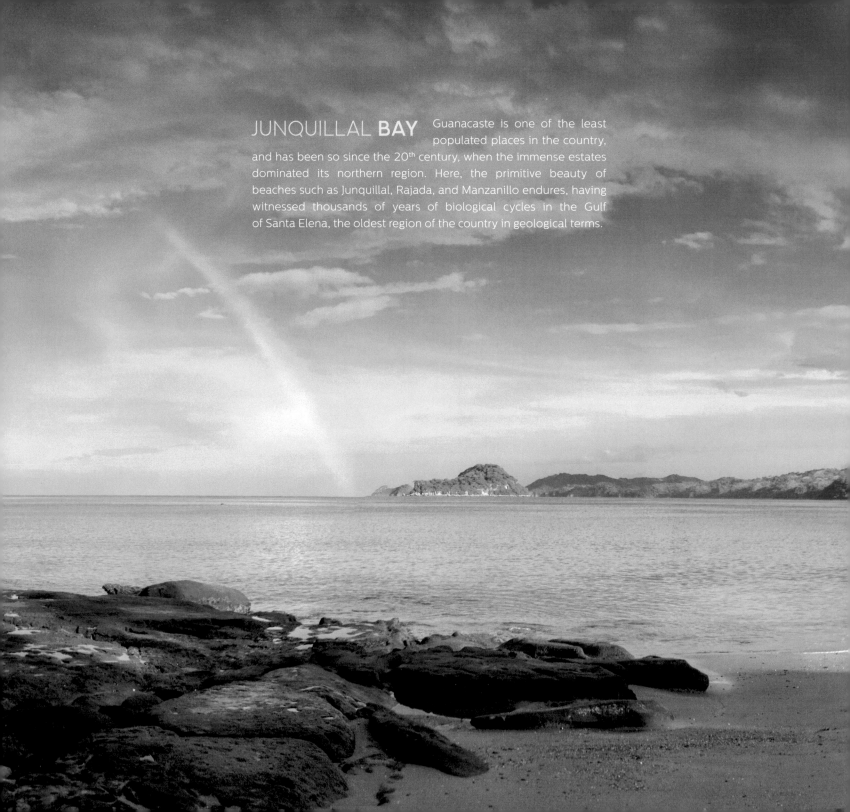

JUNQUILLAL **BAY** Guanacaste is one of the least populated places in the country, and has been so since the 20th century, when the immense estates dominated its northern region. Here, the primitive beauty of beaches such as Junquillal, Rajada, and Manzanillo endures, having witnessed thousands of years of biological cycles in the Gulf of Santa Elena, the oldest region of the country in geological terms.

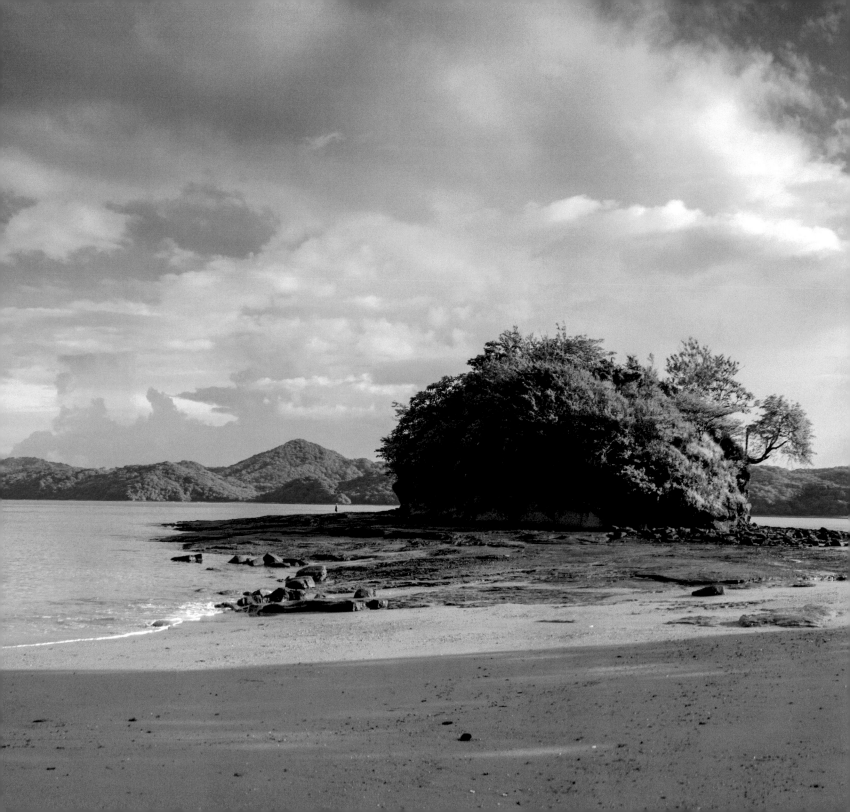

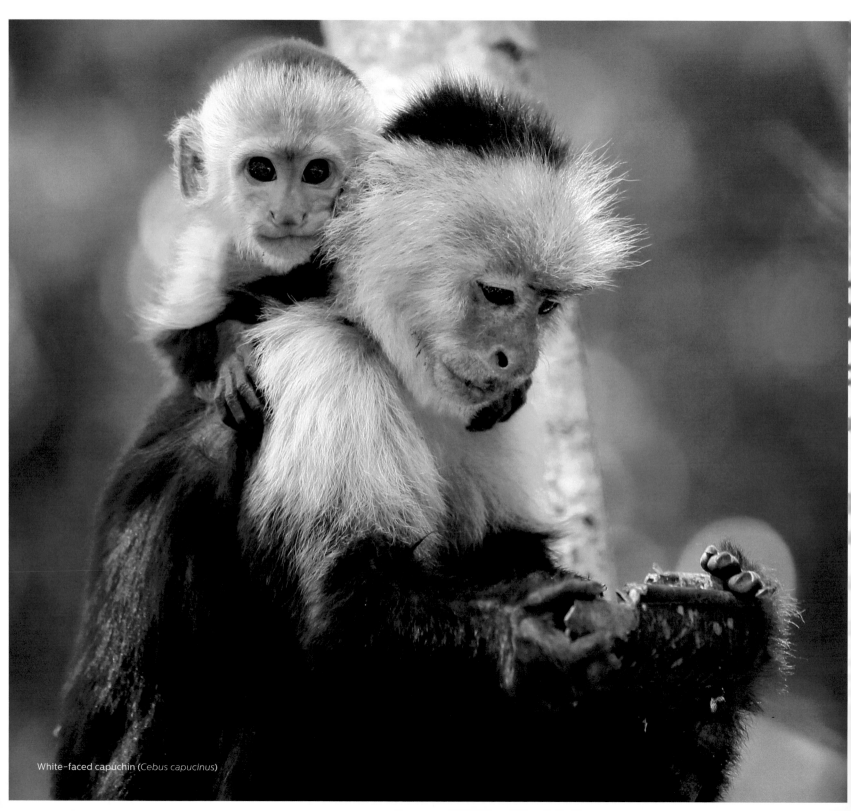

White-faced capuchin (*Cebus capucinus*)

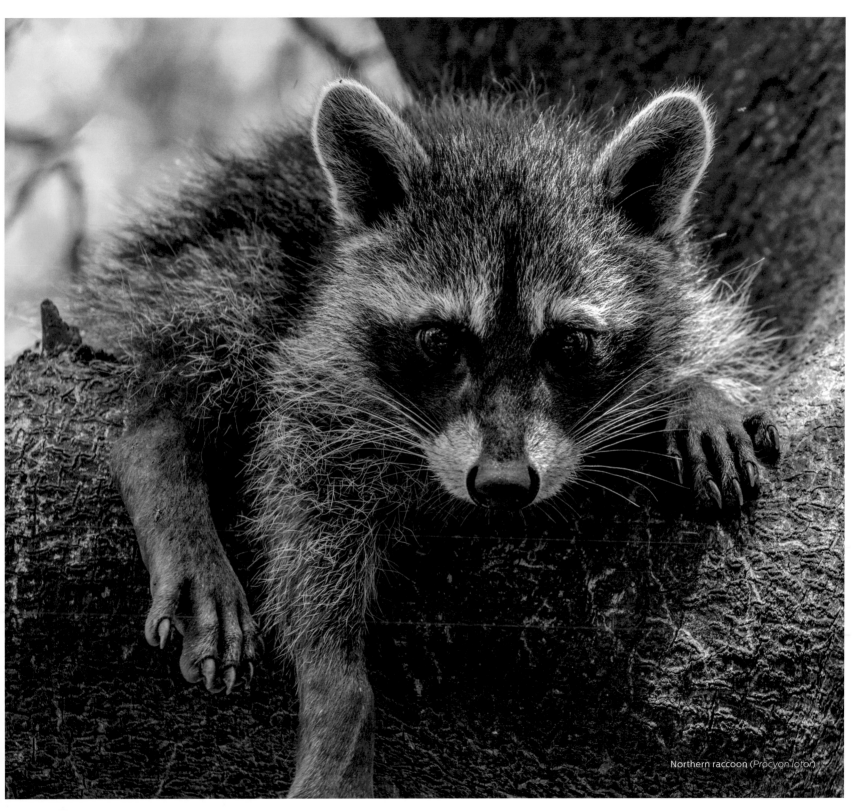

Northern raccoon (*Procyon lotor*)

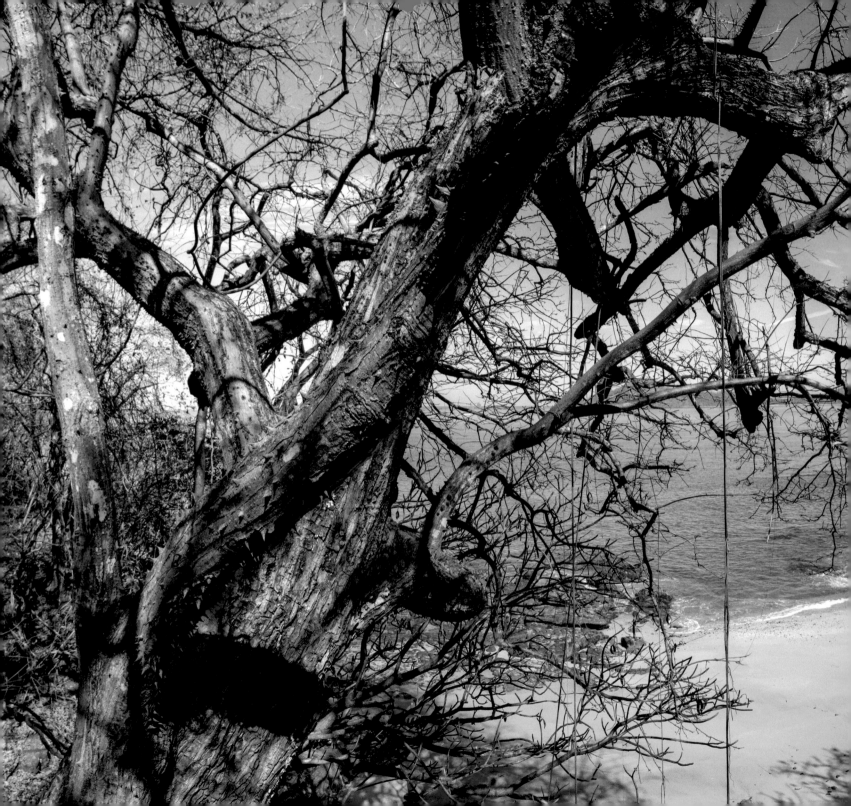

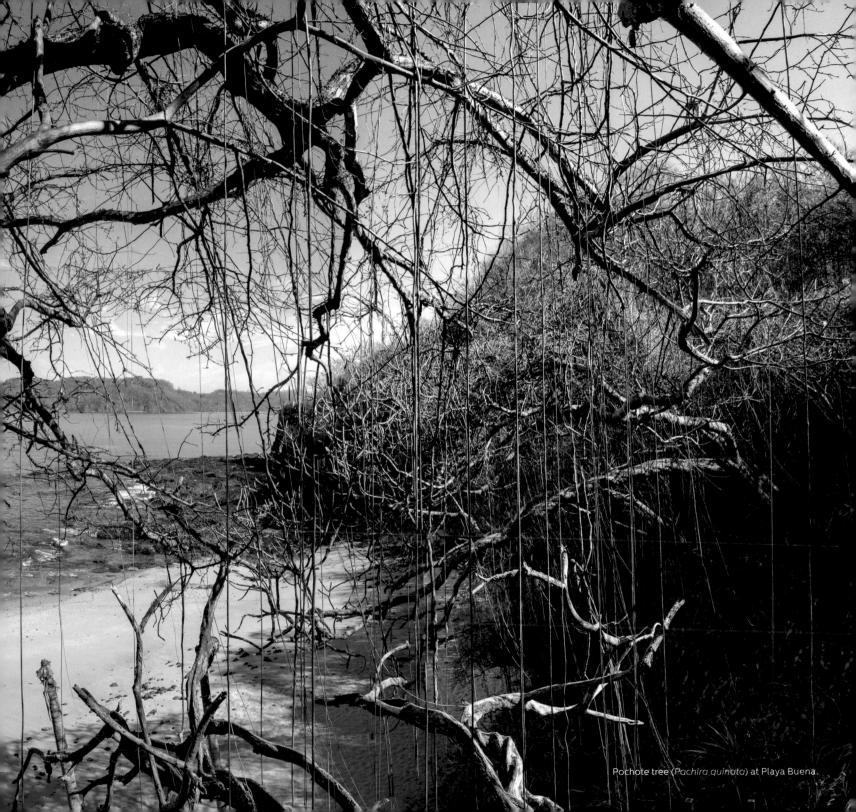

Pochote tree (*Pachira quinata*) at Playa Buena.

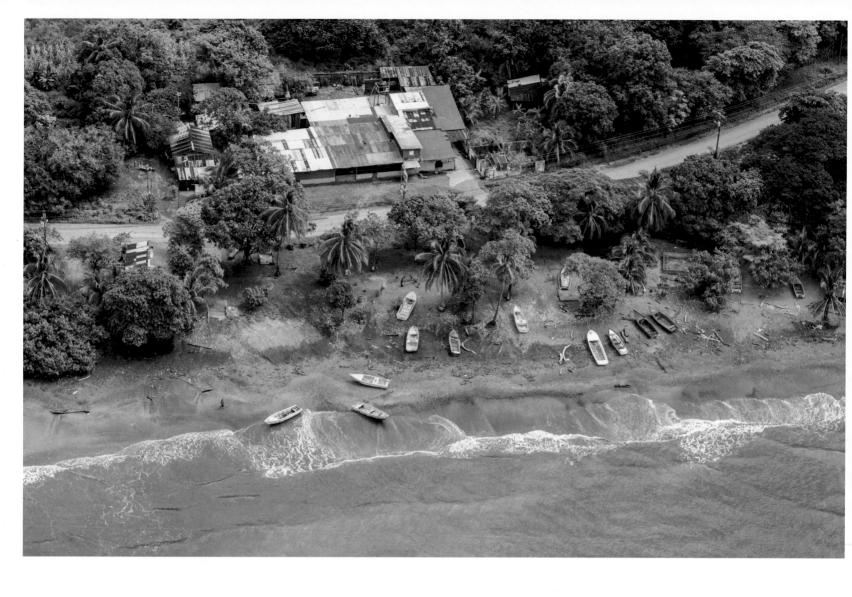

Far from major roads, the Nicoya Peninsula's 125 miles (200 km) of coastline offer small fishing villages, hidden rivers, verdant agricultural valleys, and tiny patches of tropical forest.

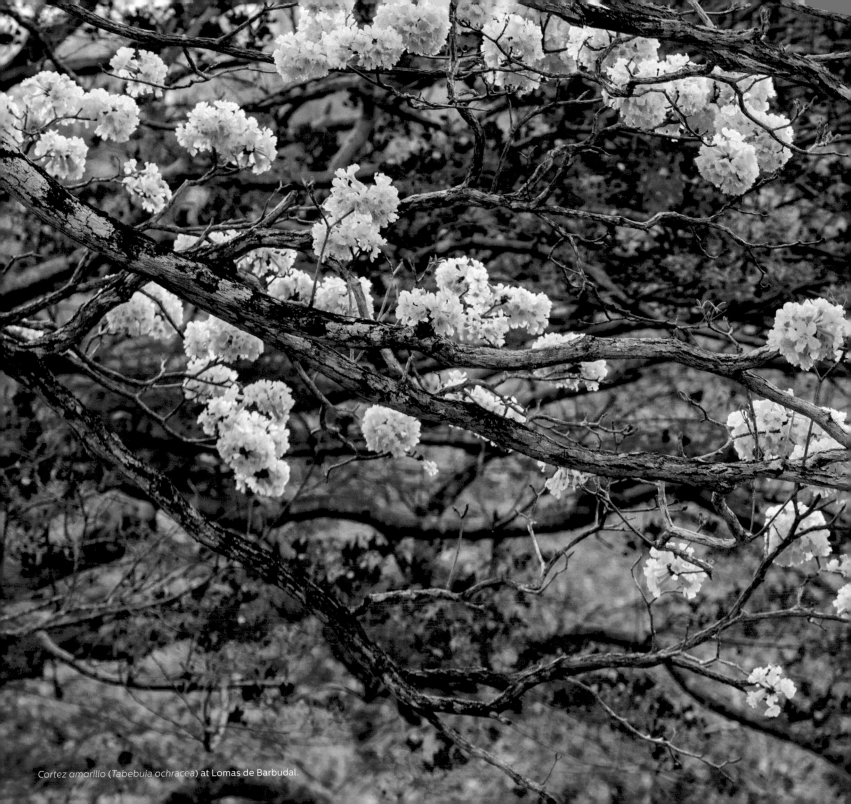

Cortez amarillo (Tabebuia ochracea) at Lomas de Barbudal.

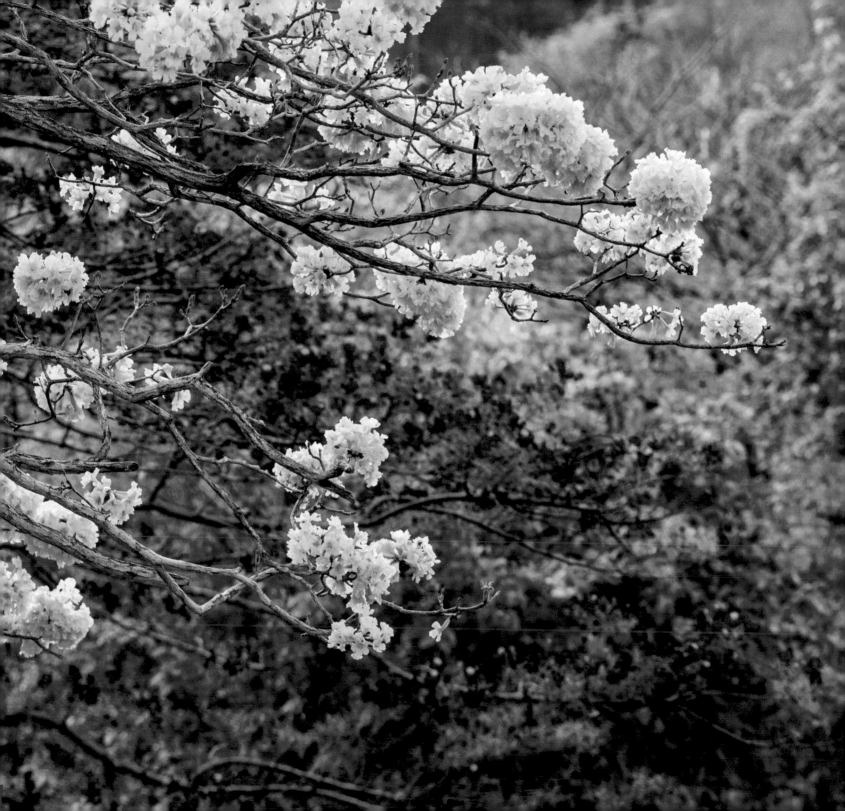

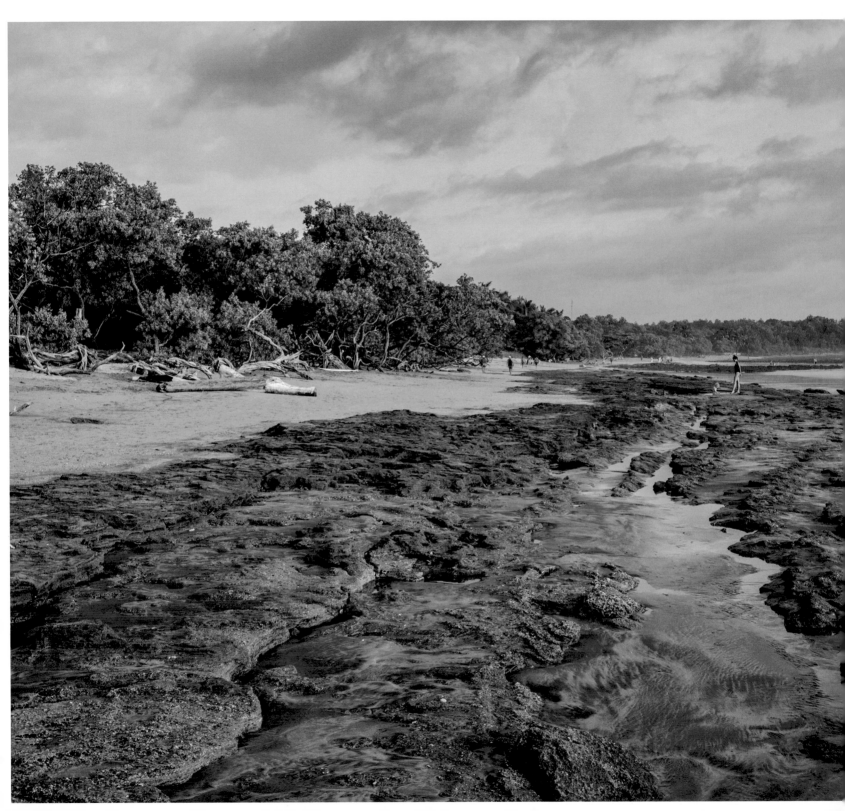

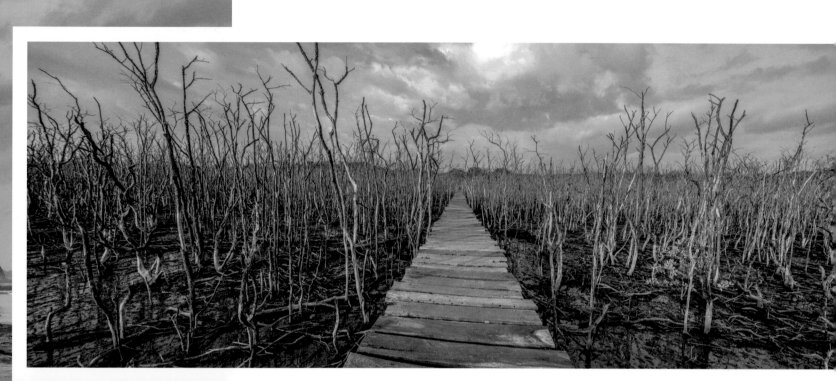

Just 30 minutes from the more visited Tamarindo, Playa Avellanas' enticing collection of both left and right breaks make it one of the best surf spots on the peninsula. A long rickety wooden walkway passes through a mangrove swamp that was cut off from sea for several months after an earthquake in 2012. Rapidly, the swamp dried up and the trees withered, leaving behind this otherworldly landscape.

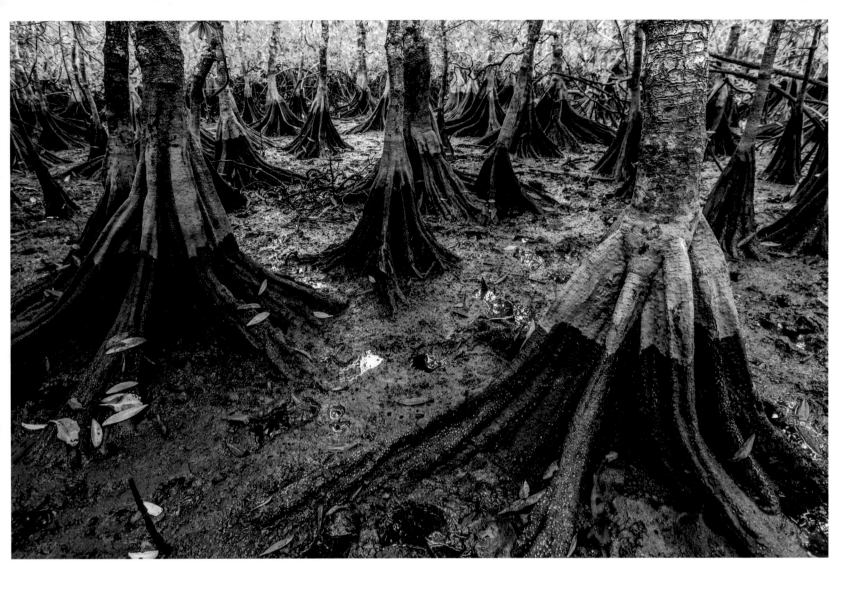

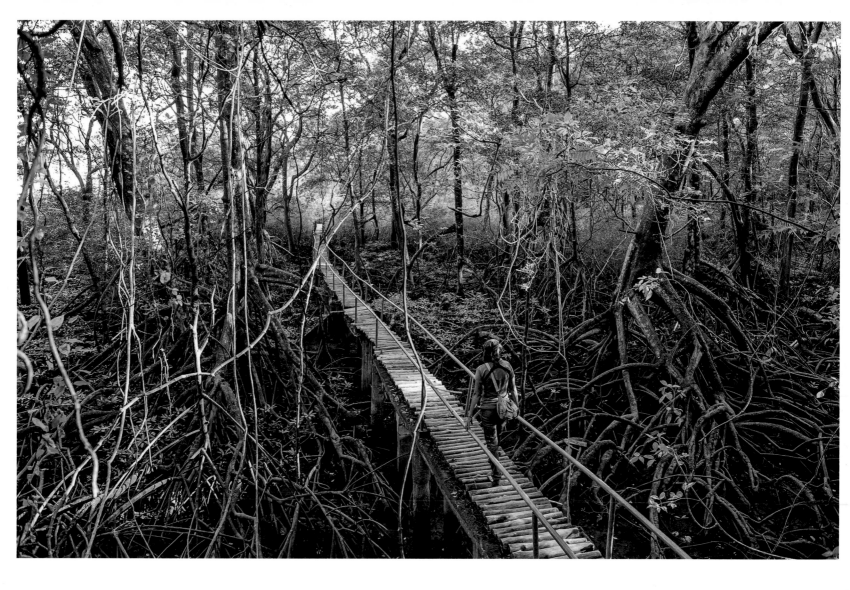

Due to certain unique geographical features, the Pacific coast of Costa Rica favors the growth of mangroves, and in this country 99% of these forests are found on the Pacific. During high tide, many gulfs, estuaries, and bays flood and feed the mangrove forests, which not only capture and fix carbon on land, but also form a buffer against natural disasters.

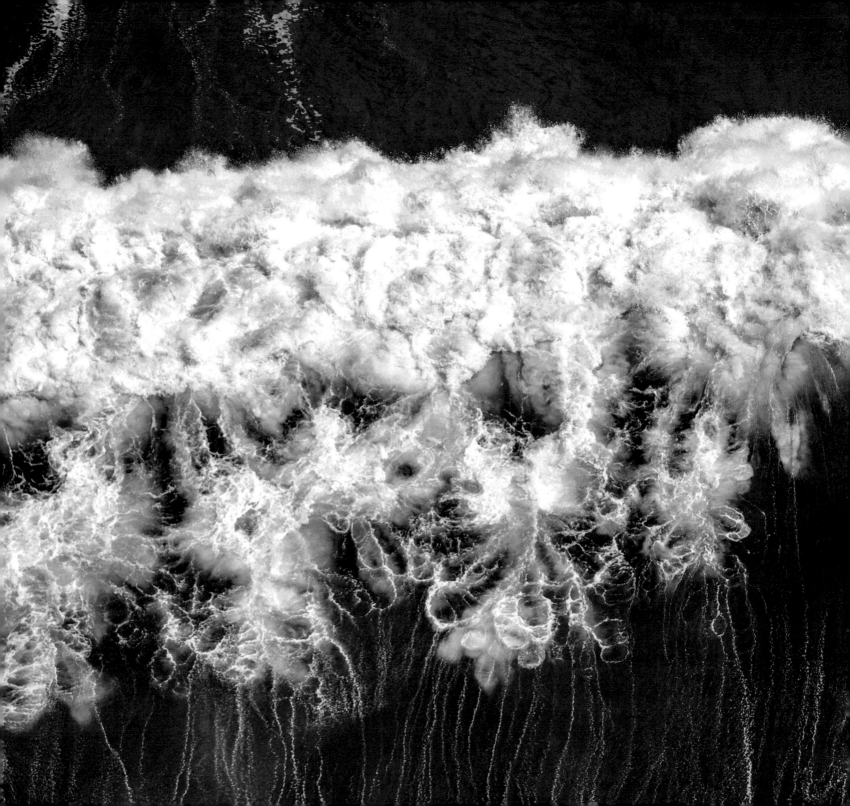

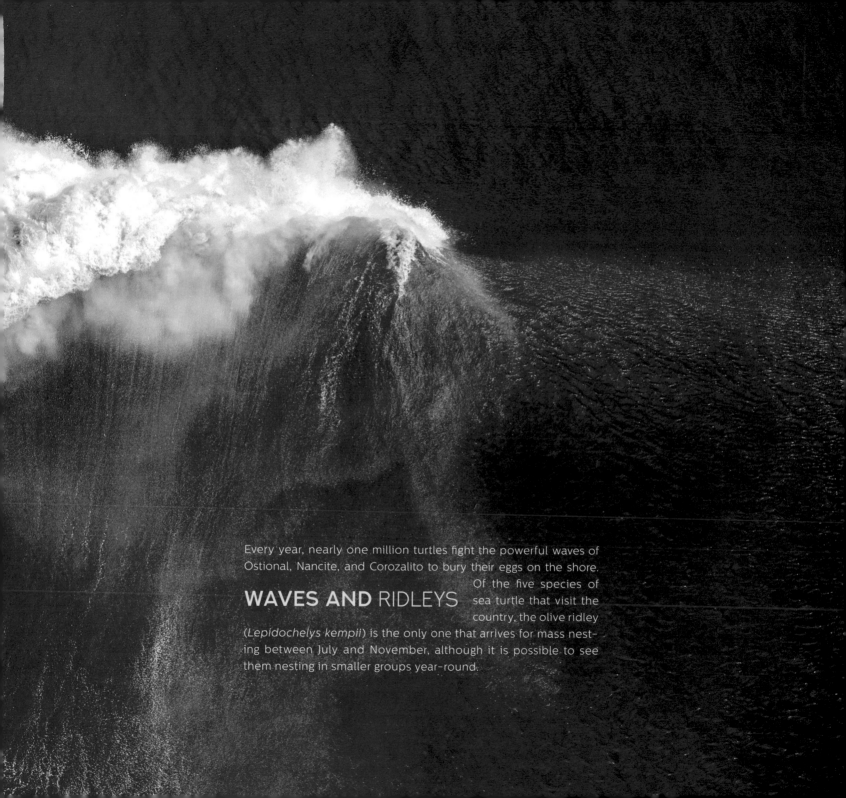

Every year, nearly one million turtles fight the powerful waves of Ostional, Nancite, and Corozalito to bury their eggs on the shore.

WAVES AND RIDLEYS

Of the five species of sea turtle that visit the country, the olive ridley (*Lepidochelys kempii*) is the only one that arrives for mass nesting between July and November, although it is possible to see them nesting in smaller groups year-round.

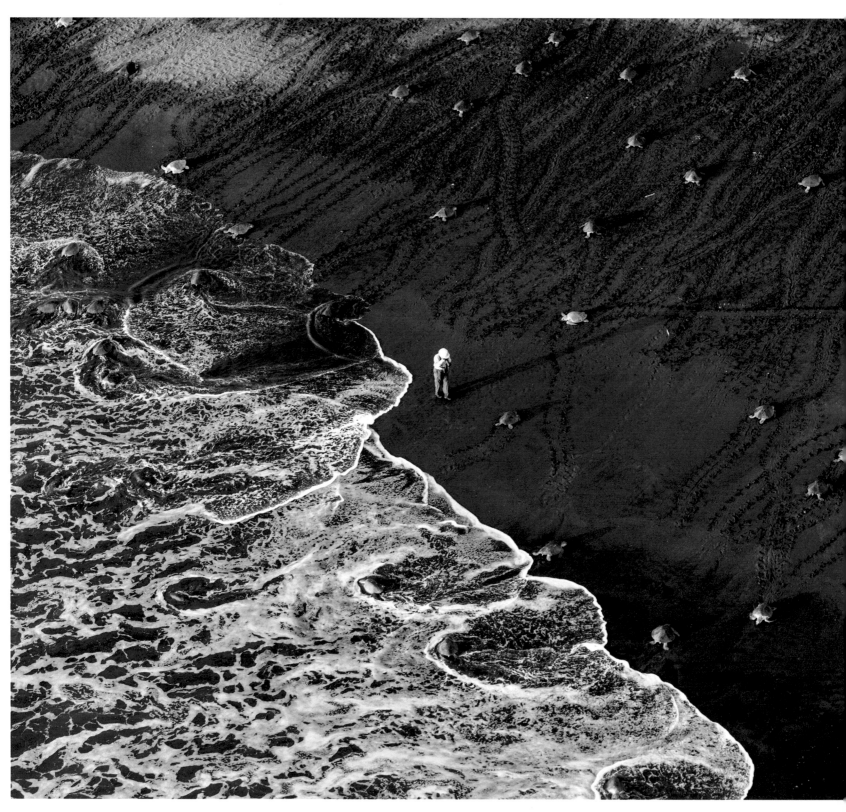

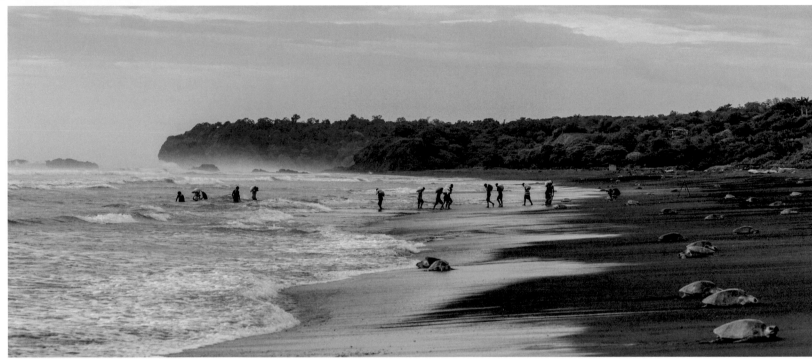

Although turtle eggs have long featured in the diet of coastal people, removing them is currently illegal in the entire country, with a sole exception, that of Ostional. This community is allowed to collect eggs during the 48 hours that follow a mass nesting; many of the eggs, biologists argue, would have been destroyed anyway by the succeeding waves of arriving turtles.

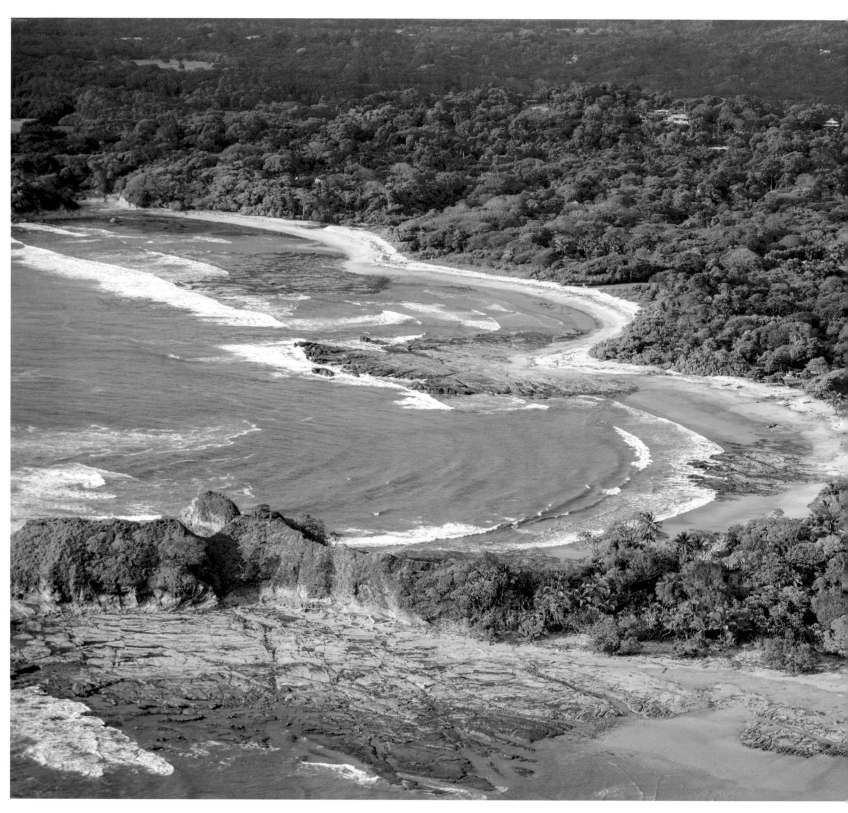

THE AMERICAN
PROJECT

Nosara has two identities, one local and one foreign. This region, founded on gold and mud by the Chorotegas 1000 years before the Spanish conquest, was bought in 1962 by a foreigner from the United States who intended to develop it into shopping malls and golf courses. Although the plan never came to fruition, this spot would become one of the oldest communities of expatriates in Costa Rica. In 1975, the Nosara Civic Association took on the management of the so-called American Project, with the goal of protecting nature and keeping the community free of large scale developments. The town has most of the amenities that the yoga lovers who flock here might want, while its beaches—Pelada, Nosara, and Guiones—leave surfers from all over the world breathless.

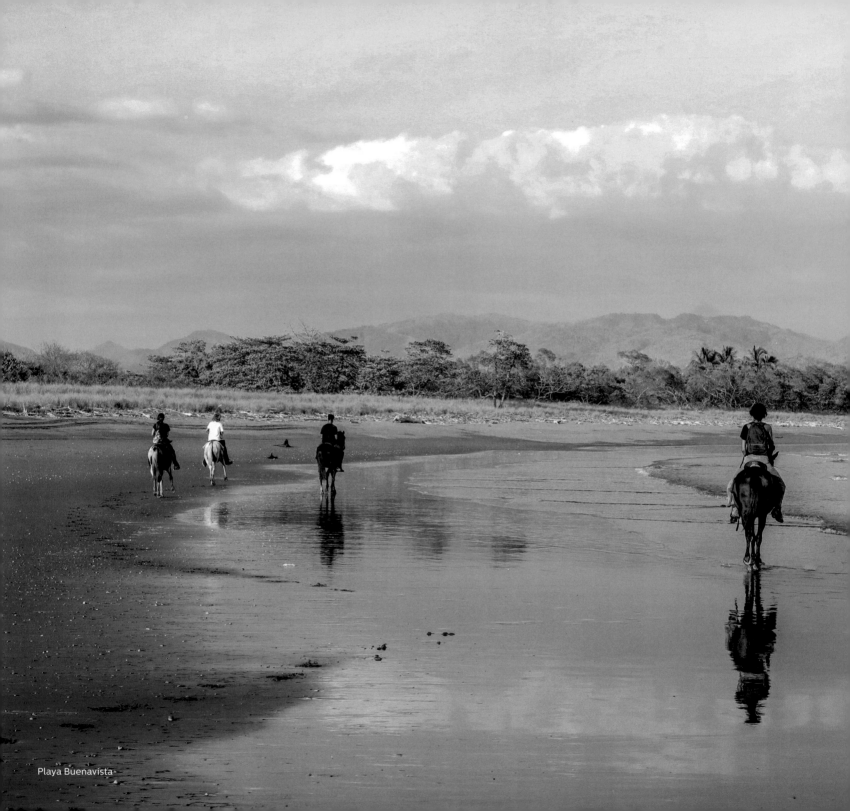

Playa Buenavista

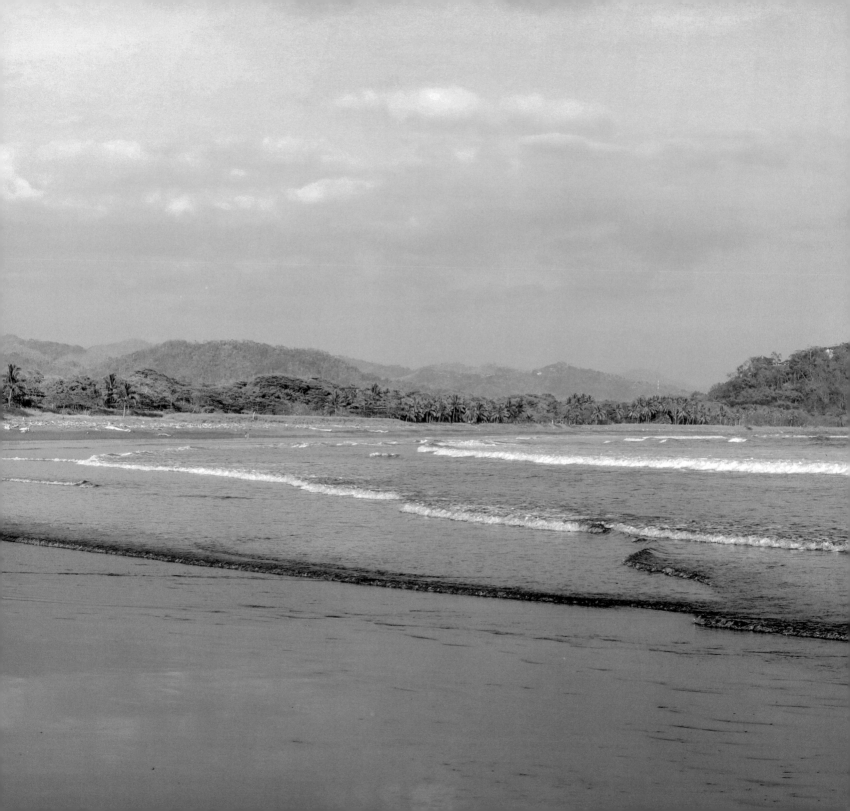

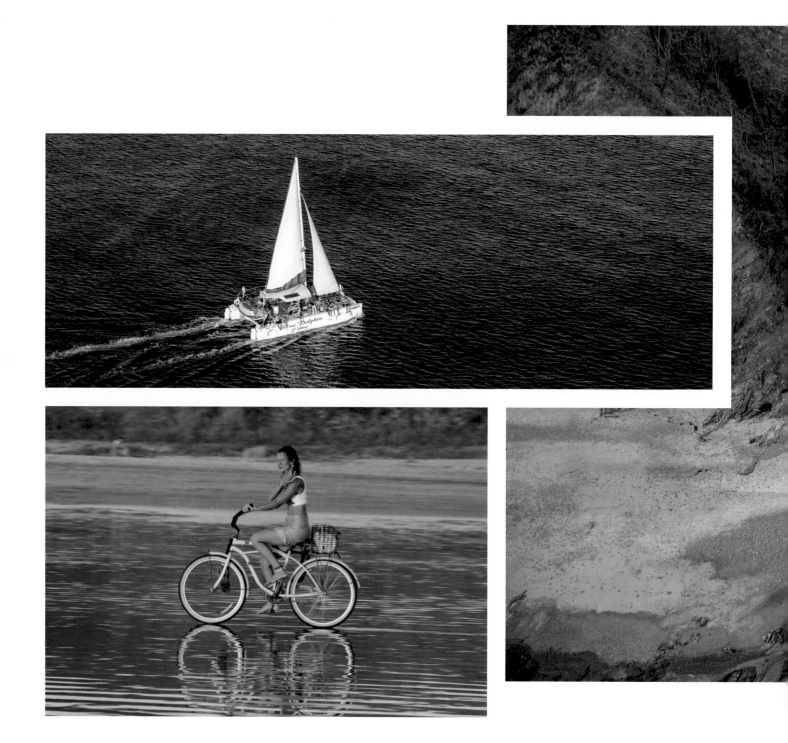

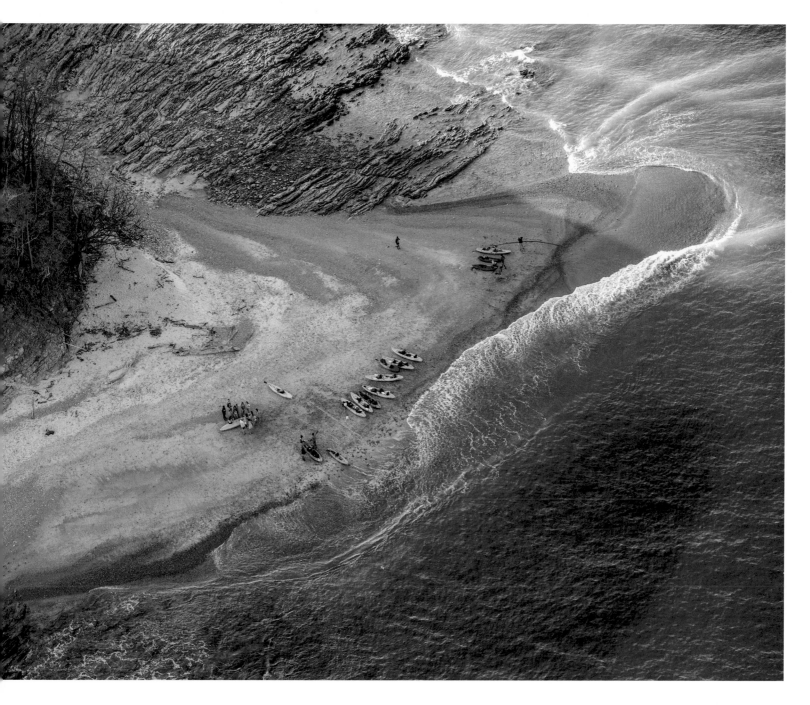

Playa Sámara and Guiones, two destinations famous for their surfing and other water sports.

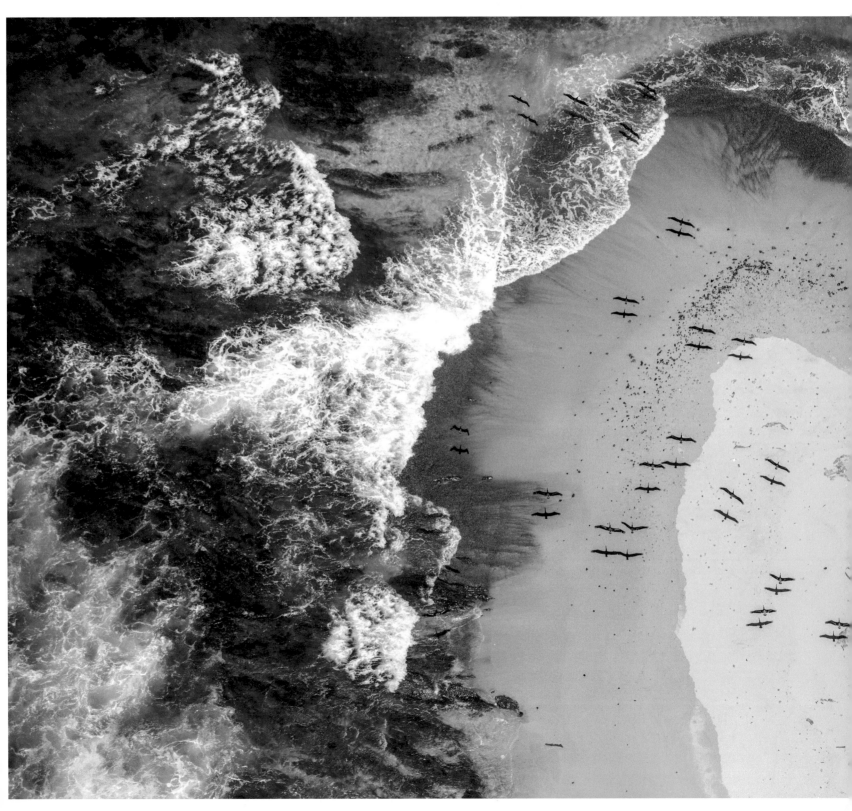

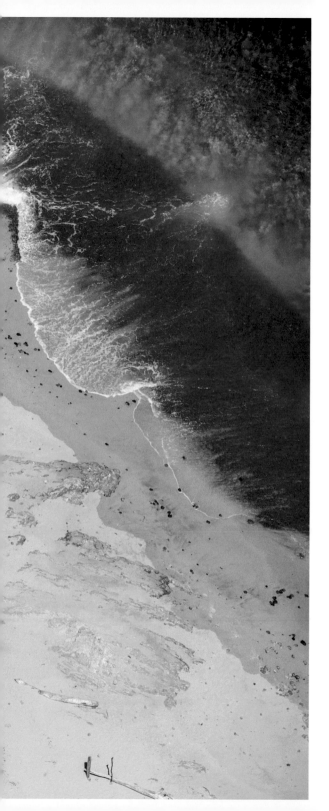

TOWARD THE SOUTH

At Playa Sámara, low tide reveals a tranquil sandbar where pelicans feed and rest, so long as tourists on jet skis or in kayaks don't scare them off.

Farther south, at the tip of the Nicoya Peninsula, there are two beaches, Santa Teresa and Montezuma (next page), that are separated by a mere 4 miles or so (7 km), but just by traveling the short distance between the two beaches, you will become witness to a confounding phenomenon: sunrise over Montezuma, which faces east, and sunset over Santa Teresa, which faces the Pacific Ocean.

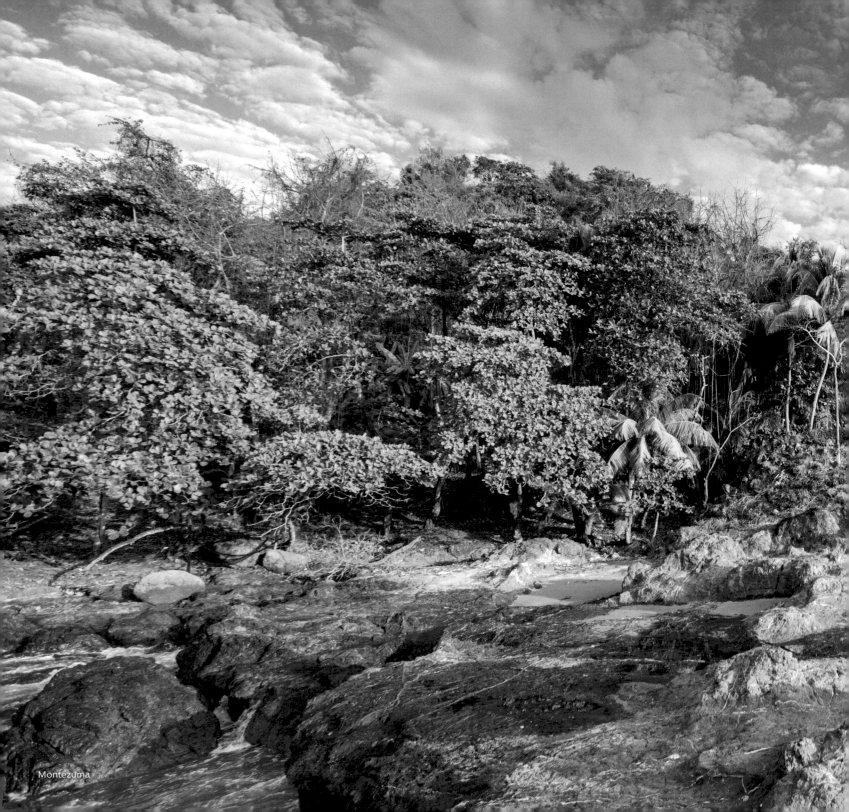
Montezuma

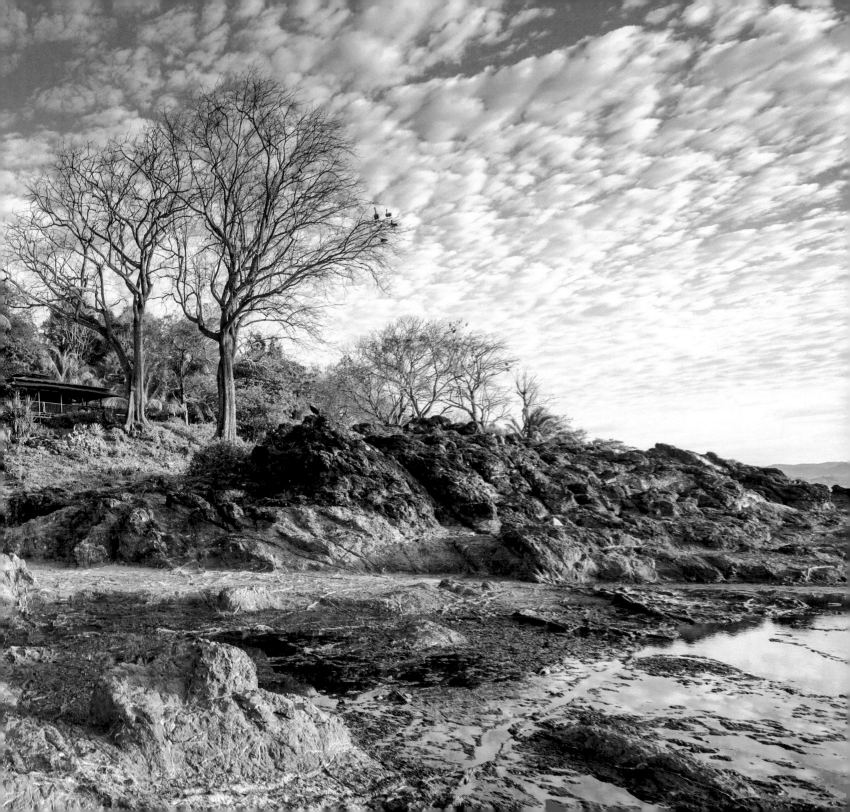

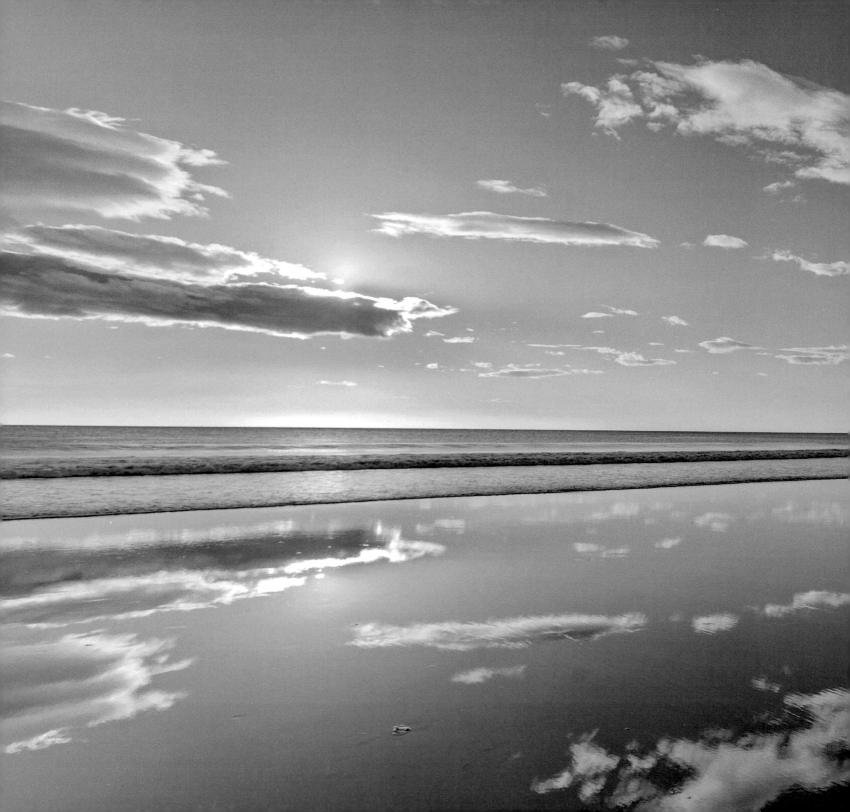

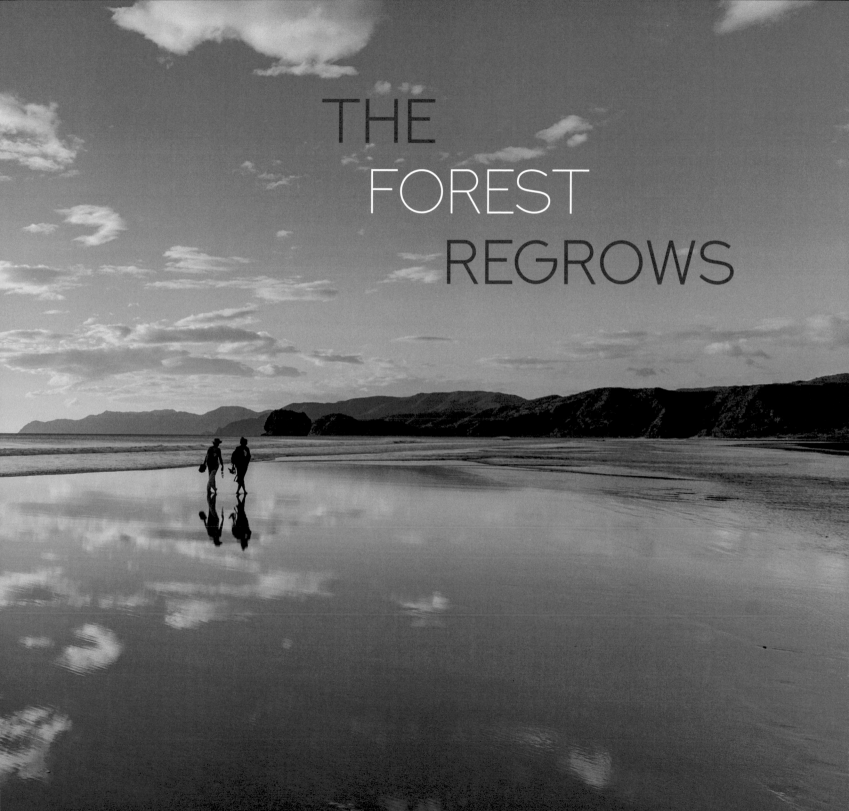

THE
FOREST
REGROWS

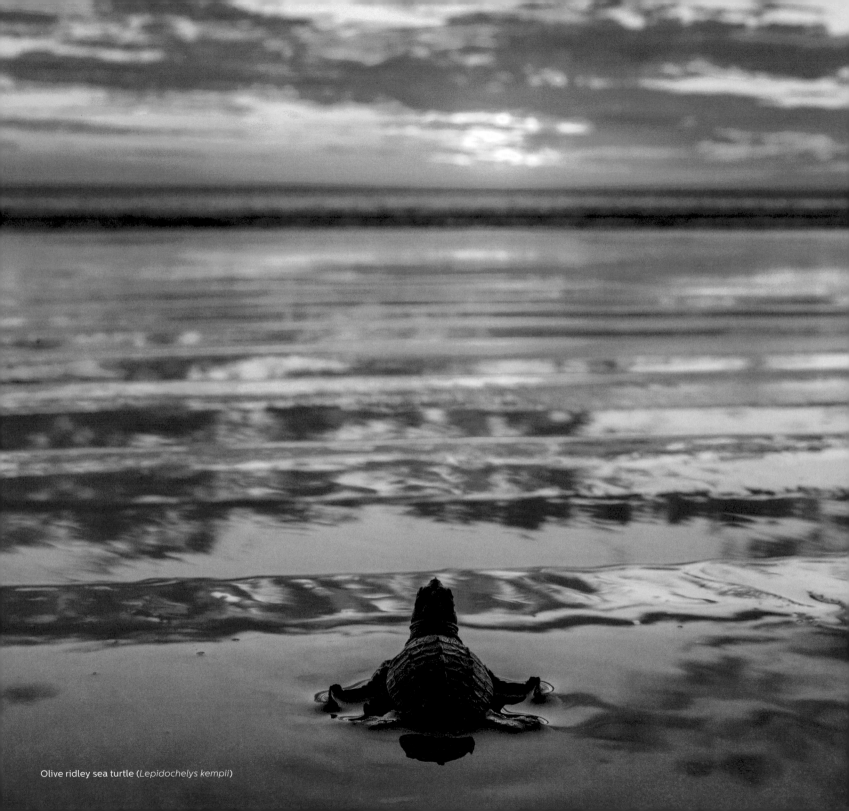

Olive ridley sea turtle (*Lepidochelys kempii*)

Located in the far northeast of Costa Rica, the Conservation Area of Guanacaste (whose Spanish acronym is ACG) is a significant presence on the Costa Rican map, indeed a gigantic patchwork of biological wealth that manifests itself in boundless ways, in the depths of the Pacific Ocean, over great plateaus hardened by the sun, on the slopes of volcanic peaks, and throughout the lush plains that roll toward the Caribbean slope.

Composed of a little more than 400,000 acres (163,000 hectares) of land and marine territory, it lies partially within the province of Guanacaste and extends northeast, venturing into various districts of the neighboring province of Alajuela, and then, after traversing the mountainous tapestry of the Pacific slope, dissipating into wetlands and plains.

A sweltering province during seven months of the year, it is dominated by 125 miles (200 km) of addictive beaches, old stately haciendas, trees with brilliantly red leaves, and immense rice fields that seem to extend beyond the horizon.

A land where *sabaneros* (cowboys) cross paths with surfers, the *pampa*, as *guanacastecos* call their great plains, is dry and scorchingly hot.

Nonetheless, along the eastern border of the ACG, in the canton of Upala, wind, rain, and rivers have created environments saturated with water, irrigating volcanic paths lined with lush vegetation that look nothing like the landscape of the plains.

The biography of the Mesoamerican dry forest, whose history goes back some 500 years, lives on in the hottest landscapes in the north Pacific region of Costa Rica, which are also part of the Conservation Area of Guanacaste.

In reality, what we now consider the "great plains" of Guanacaste are not a natural habitat but merely the consequences of a history of cattle ranching and agriculture on lands that were once covered by the most extensive ecosystem in the Pacific region of Mesoamerica, the tropical dry forest.

In the early 20th century, this dry forest was still a healthy and spectacularly large habitat, from Sinaloa in Mexico to northern Bolivia, inhabited by hundreds of thousands of species. Back then, the western coasts of much of Mexico and Central America exhibited the harsh beauty of this ecosystem, which included coastal plains, turtle nesting sites, and magnificent, centuries-old, evergreen trees.

Until the 1960s, Guanacaste was almost entirely covered by dry forest, but deforestation and the rise of large-scale cattle ranches, along with new land use patterns, turned the "jungle" into an endless succession of pastures and monocultures.

In 20 years, 40% of the province of Guanacaste lost its forest cover, which was cleared to make way for *pampas* strewn with fallen trees and cattle that supplied cheap meat for the emerging fast food industry. Driven by the dogma of immediate returns, investors turned the land into a quilt of forest remnants, barbed wire fencing, pastures, African grasses to feed cattle, and the shade of the odd surviving guanacaste tree, creating the landscape we know today.

But in 1966, at a cattle estate in the northern Guanacaste lowlands, a seed was sown that would lead to dramatic changes. This ranch, known as Hacienda Santa Rosa, which was

once so vast it extended from a high in-land plateau to the seashore, had a combination of unique features: a recorded history, patrimonial value, scenic beauty, and natural resources.

Traveling back in time, to March 20th, 1856, this hacienda becomes the setting of what is now a legendary battle between the invading mercenary forces of William Walker, who had proclaimed himself president of Nicaragua, and the troops of the Costa Rican army, commanded by José Joaquín Mora. The hacienda, a splendid colonial mansion, or casona, built of gnarled wood and with stone corrals, today stands as a memorial to the subsequent victory of the ticos over William Walker and his band of mercenaries.

The ACG (Conservation Area of Guanacaste) was founded at this site, which would become the location of two later battles, in 1919 and 1955, in which groups backed by Nicaraguan forces would attempt, unsuccessfully, a coup d'état. The memory of these battles has not only played a role in shaping Costa Rican identity but also undoubtedly encouraged the protection of the natural beauty surrounding it.

In 1966, the casona was declared a national monument, and later, in 1971, what had been a cattle hacienda for 400 years, made up of pasture dotted with patches of remnant dry forest, became one of the first national parks in the country. Through the perseverance of biologists and other scientists, conservationists, and government officials, the initial 25,000 acres (10,115 hectares) grew, crossed beyond the Pan-American Highway, and incorporated marine territory, so that today the park includes a staggering 105,000 acres (43,000 hectares) of marine territory and nearly 300,000 acres (120,000 hectares) of land.

After having created the conditions in which plants and animals could reproduce in relatively pristine environments, the ACG would have to face an implacable and nearly constant enemy: fire.

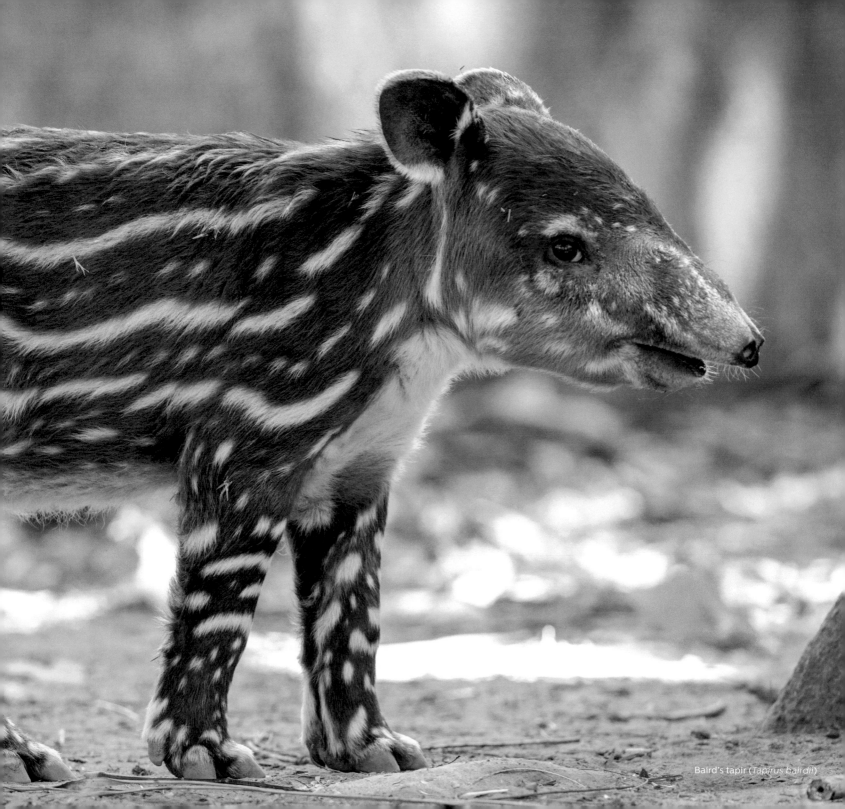

Baird's tapir (*Tapirus bairdii*)

Since Pre-Columbian times, indigenous peoples in Guanacaste burned fields intentionally, a practice that has persisted as a part of local culture until today. Burns are used to clear cropland, eliminate pests, and, especially, to stop the forest from slowly encroaching on pastures (many dry forest trees disperse their seeds using the same winds that, year after year, roil the deep waters off the coasts). But, when poorly managed, planned burns get out of control and result in huge fires each year.

Based on studies of seed propagation by ecologists Daniel Janzen and Winnie Hallwachs, the ACG adopted an unprecedented two-pronged conservation strategy: the use of brigades of wildland firefighters to control fires and allowing trees to colonize pastures, relying on the natural capacity of the forest to regenerate on its own.

As the first shrubs and seedlings began to grow, the resident animals—seed carriers themselves—began to venture in, thus leading to the second step in the exceedingly slow process of regeneration; it takes from 200 to 300 years for dry forest to return to its original state.

Today, a little more than 30 years later, the dry forest, to all appearances, has won the battle against the grasslands, and is the undisputed protagonist of the landscape. The jaguars and peccary, species that need large spaces in order to overcome seasonal changes and to guarantee gene transfer, roam freely over the 300,000 acres (120,000 hectares) of the park.

The ACG is the only park in the Americas that links together four of the main tropical ecosystems: coastal-marine, dry forest, cloud forest, and rainforest, providing a home for about 335,000 species of terrestrial organisms (more than all the species in northern Mexico, the United States, and Canada combined), which corresponds to 2.6% of the world's biodiversity.

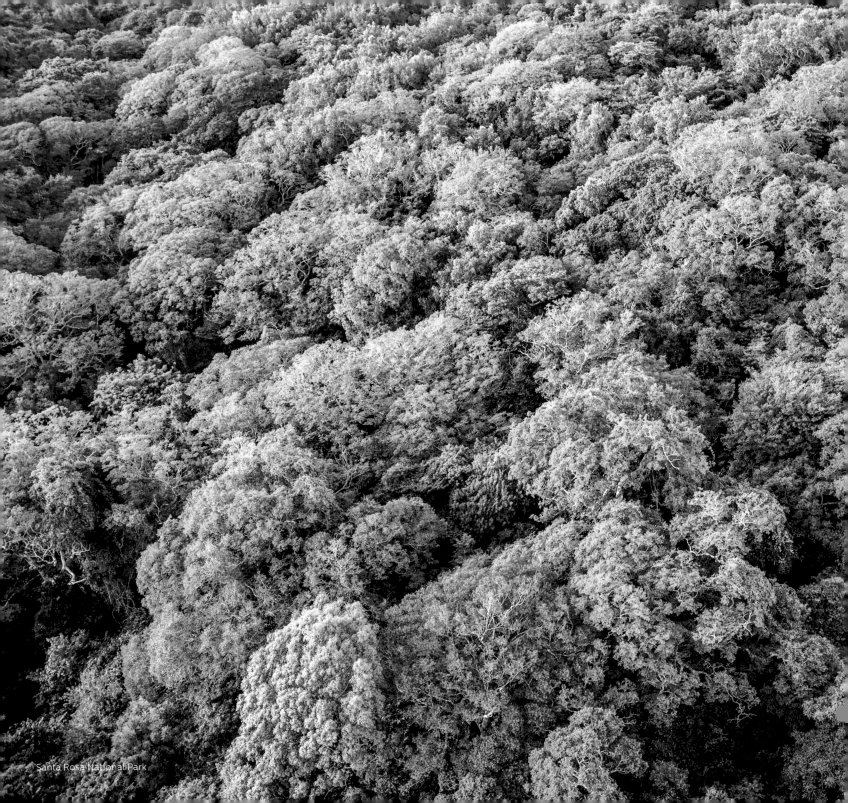

Santa Rosa National Park

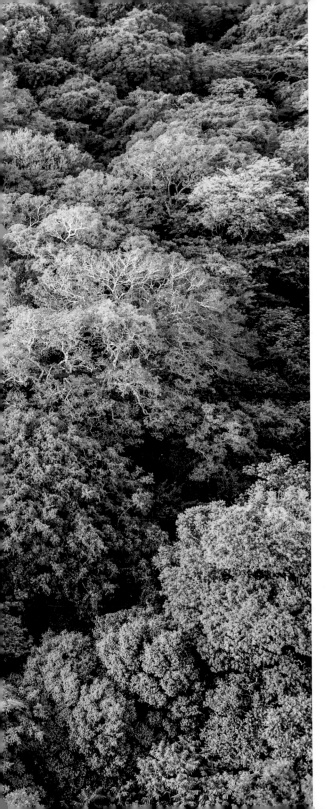

No other local or regional project had set out to secure in perpetuity a wilderness area of this scale and diversity, all based on the premise that biological cycles are interrelated and the regeneration of an isolated territory is a lot more complex.

After roughly 30 years of conservation efforts, the signs of recovery indicate that the best way to restore a degraded ecosystem, no matter how damaged, is to connect it to a preserved one, no matter how small.

In attempting to study the infinitely complex web of relationships in the Conservation Area of Guanacaste and to develop ever better methods of conservation, one eventually comes to realize that it is only nature who does not make mistakes when drawing a border.

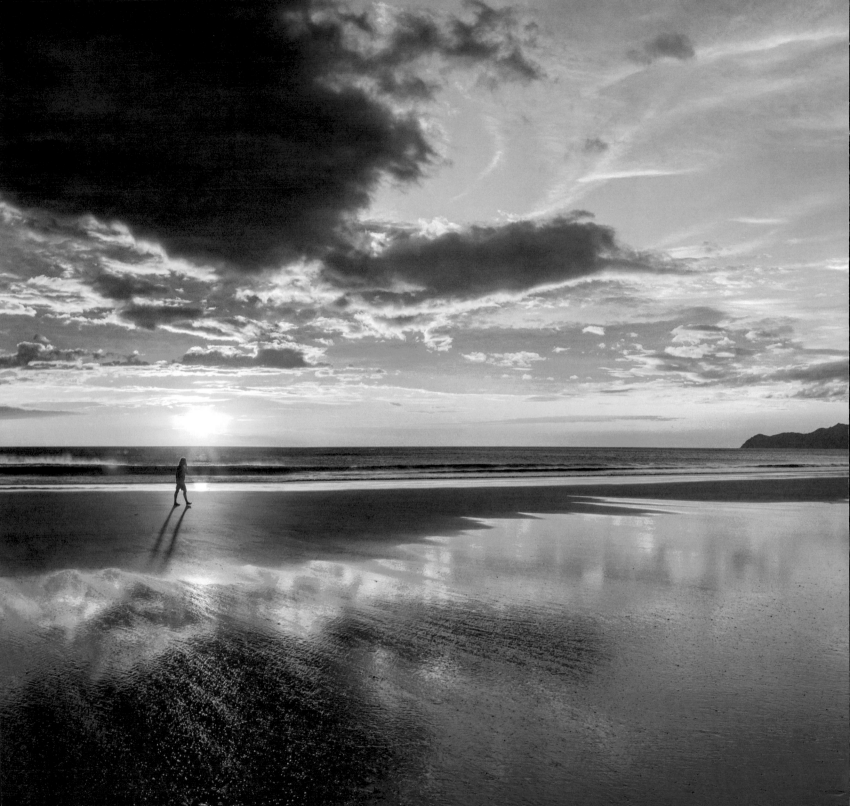

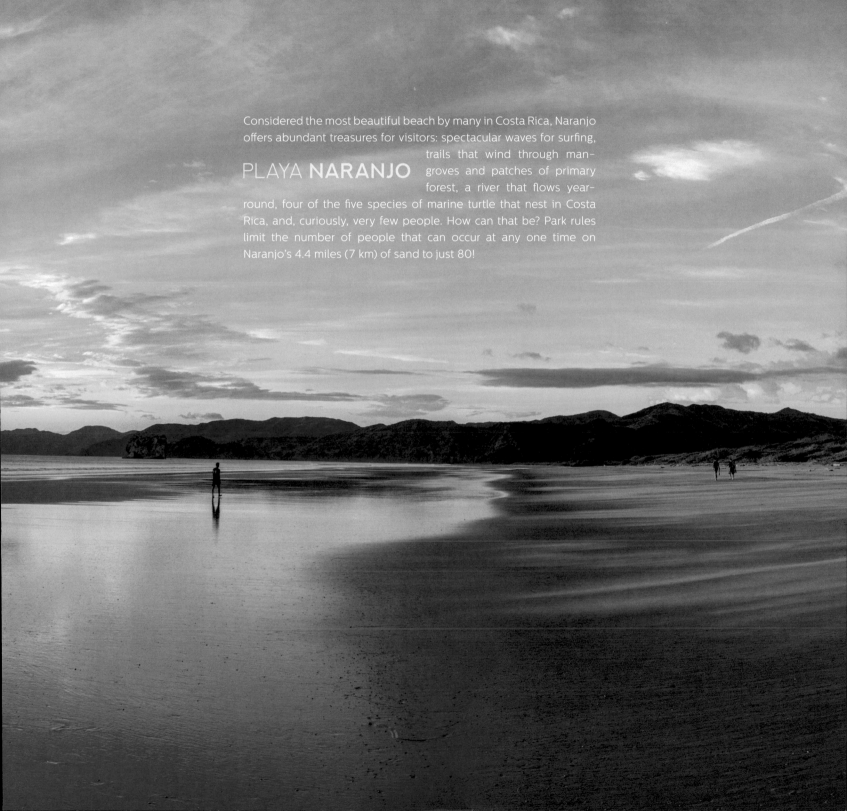

Considered the most beautiful beach by many in Costa Rica, Naranjo offers abundant treasures for visitors: spectacular waves for surfing, trails that wind through mangroves and patches of primary forest, a river that flows year-round, four of the five species of marine turtle that nest in Costa Rica, and, curiously, very few people. How can that be? Park rules limit the number of people that can occur at any one time on Naranjo's 4.4 miles (7 km) of sand to just 80!

PLAYA **NARANJO**

WITCH'S ROCK

Witch's Rock, at Playa Naranjo, and Ollie's Point, at Potrero Grande, are world renowned surf sanctuaries named after two practitioners of the dark arts. According to local lore, a sorceress lived inside Witch's Rock, which indeed does sometimes emit ghostly cries; in reality, this enormous rock in the middle of the ocean functions like a stone ocarina played by the wind. Ollie's Point gets its name from former United States Marine Corps lieutenant colonel Oliver North, who, in the 1980s, directed an undercover operation from Potrero Grande to supply arms to the Nicaraguan Contras, a key element of the Iran-Contra affair, one of the most baroque political scandals of the second half of the 20th century.

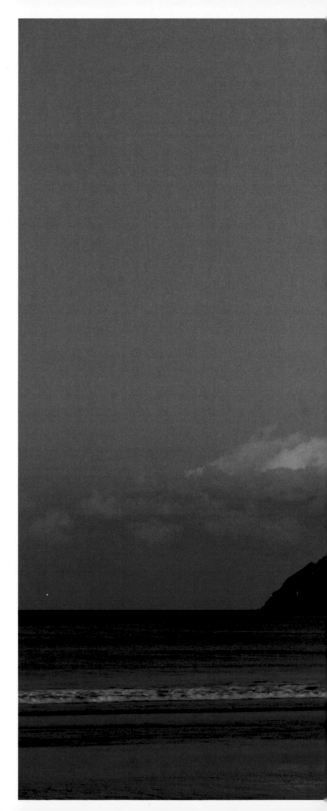

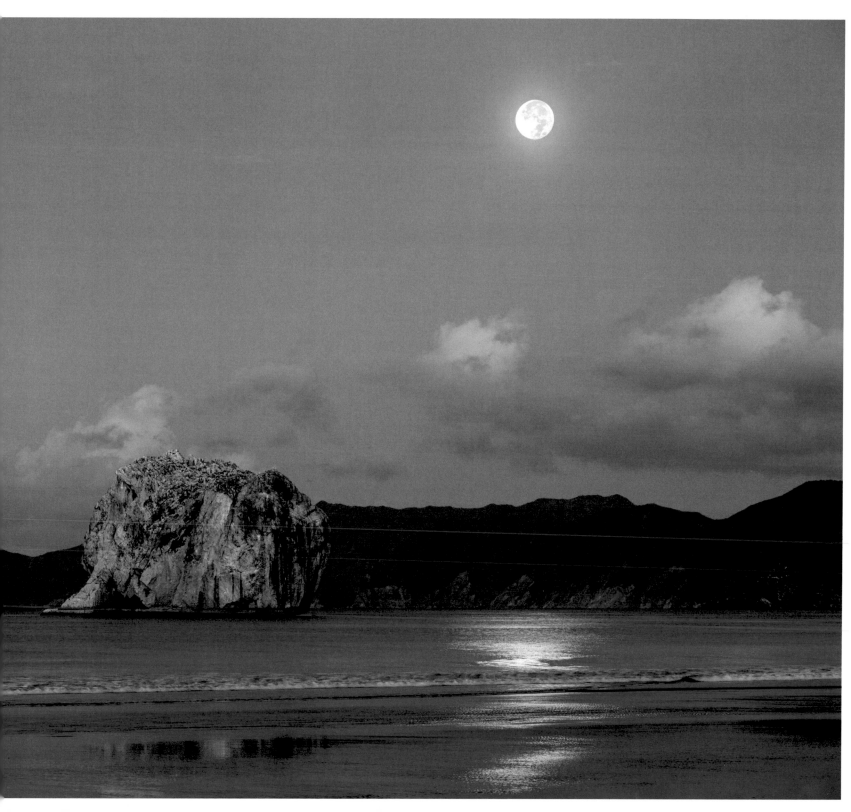

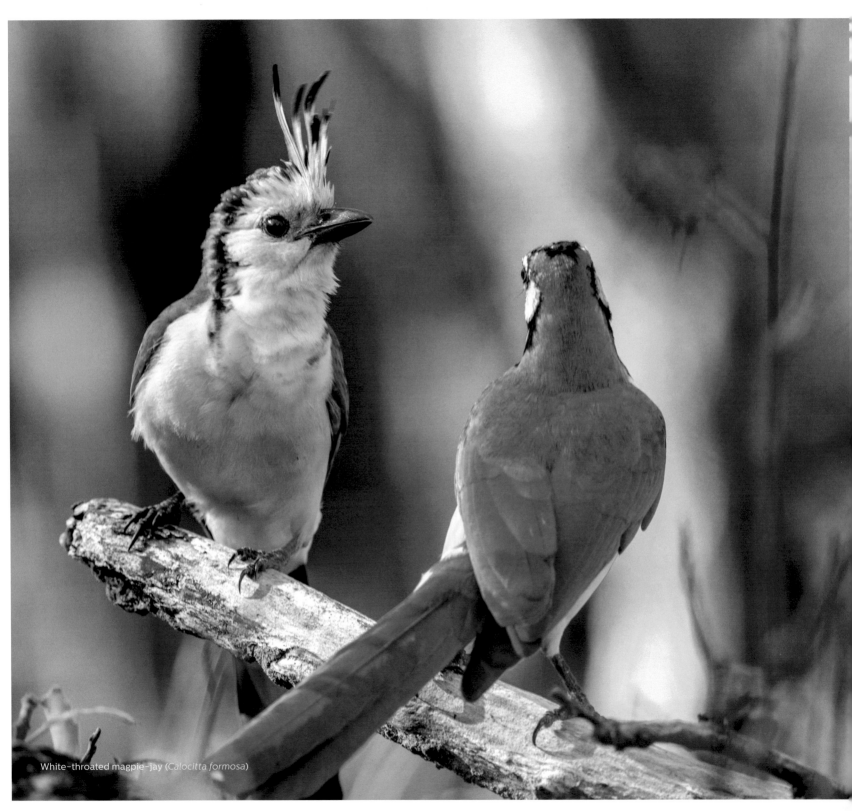

White-throated magpie-jay (*Calocitta formosa*)

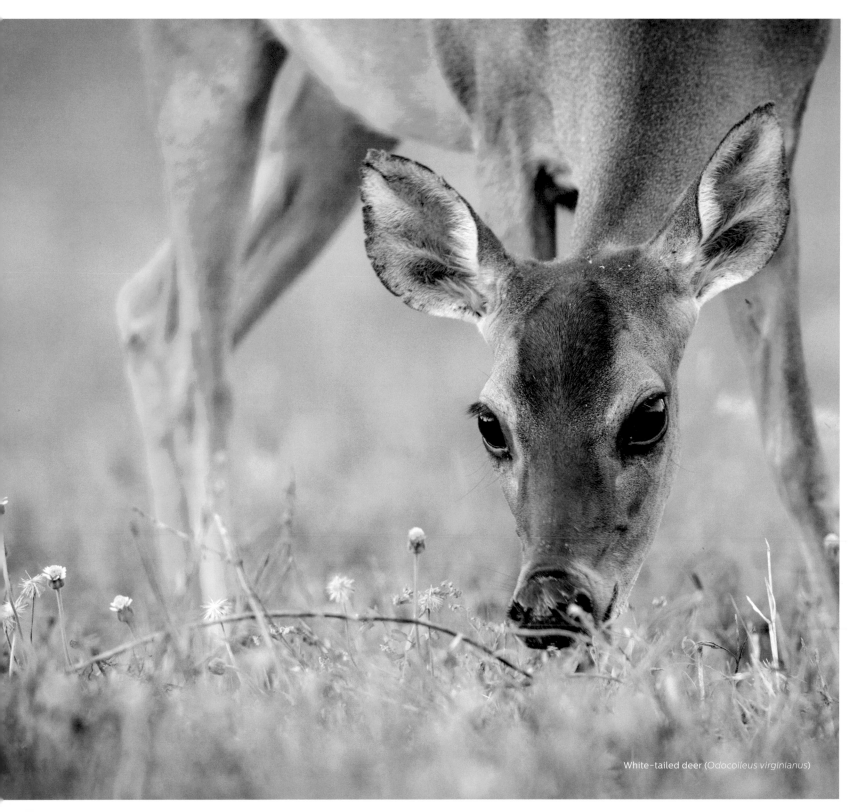

White-tailed deer (*Odocoileus virginianus*)

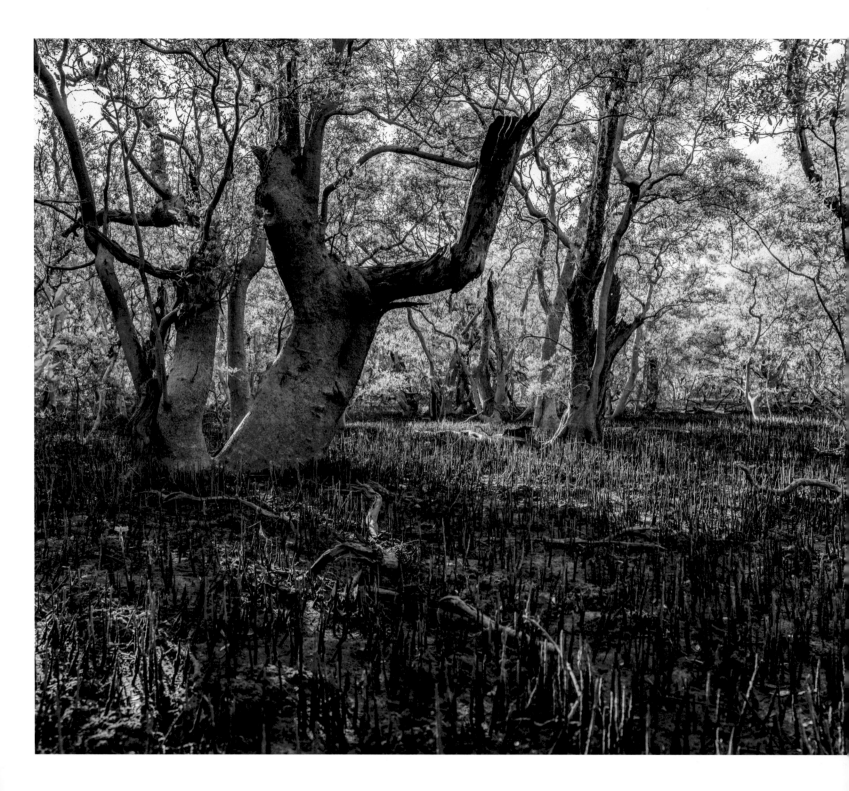

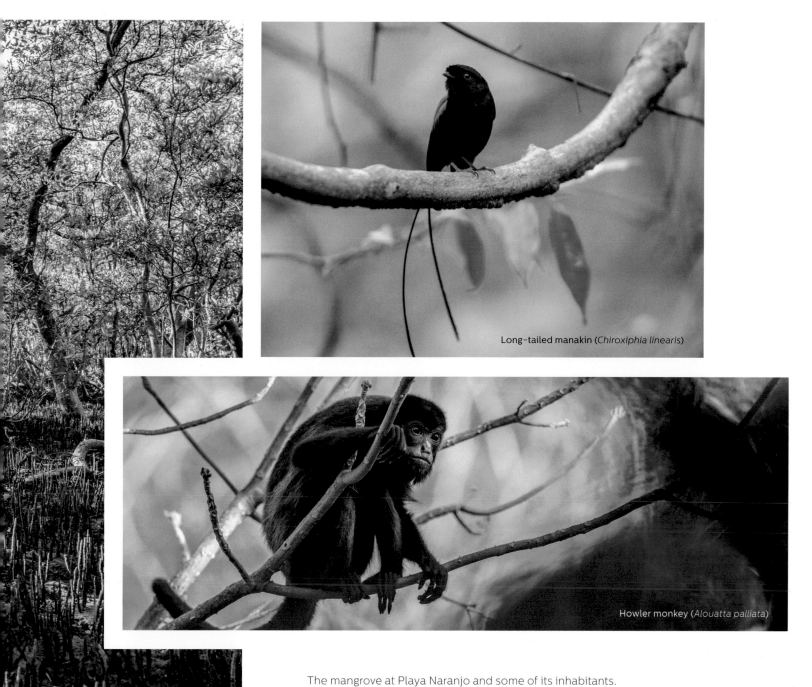

Long-tailed manakin (*Chiroxiphia linearis*)

Howler monkey (*Alouatta palliata*)

The mangrove at Playa Naranjo and some of its inhabitants.

Playa Naranjo

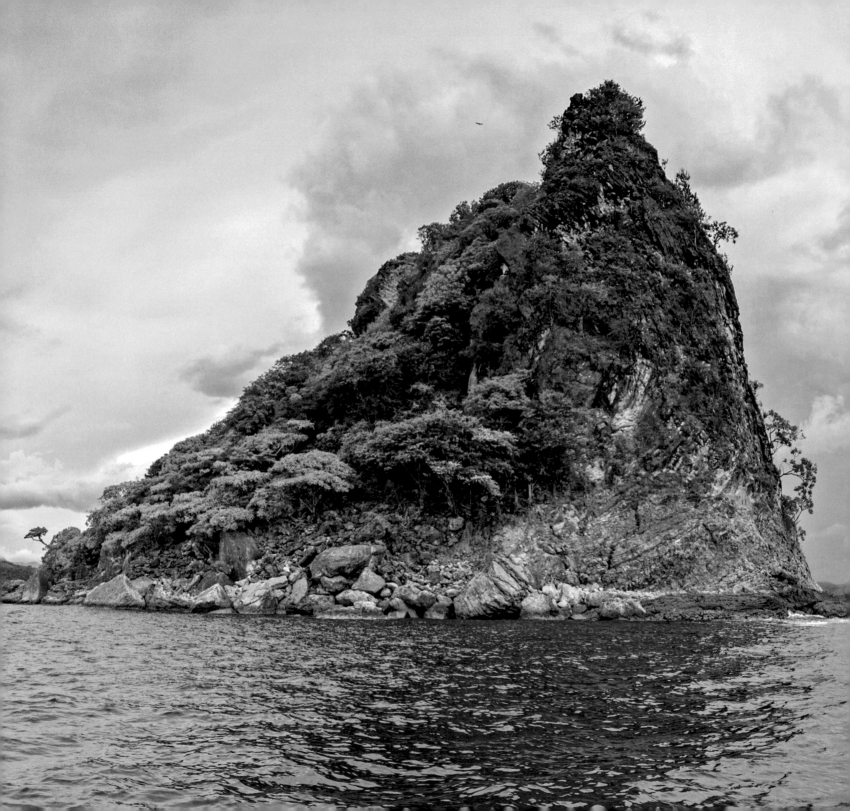

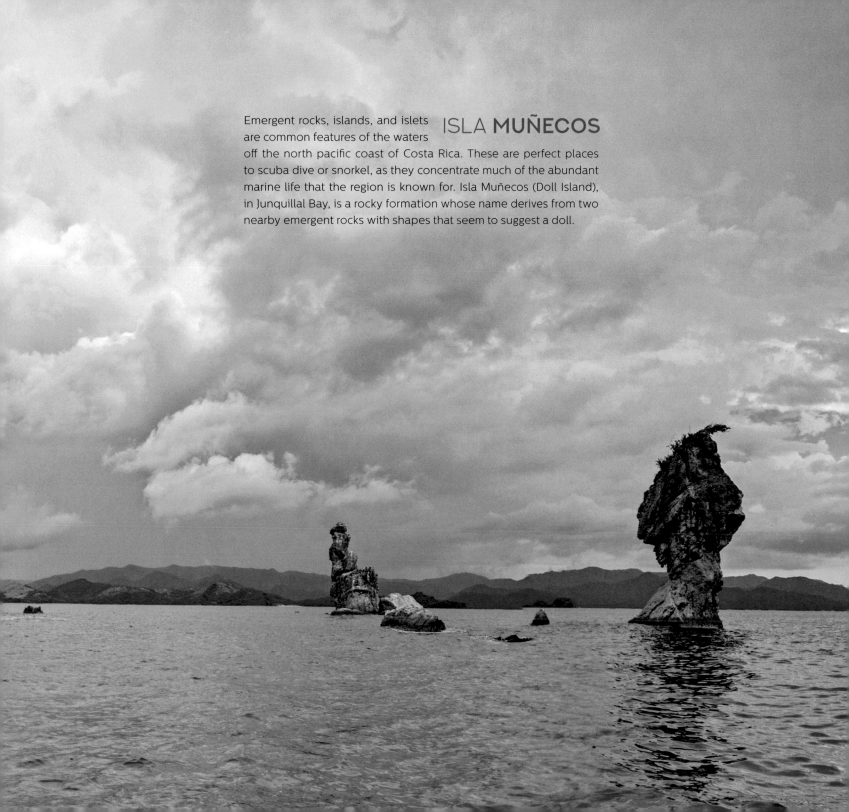

ISLA **MUÑECOS**

Emergent rocks, islands, and islets are common features of the waters off the north pacific coast of Costa Rica. These are perfect places to scuba dive or snorkel, as they concentrate much of the abundant marine life that the region is known for. Isla Muñecos (Doll Island), in Junquillal Bay, is a rocky formation whose name derives from two nearby emergent rocks with shapes that seem to suggest a doll.

SANTA ROSA

Essential elements of Costa Rican identity are at play at the ancient Santa Rosa Hacienda. Since 1570, when it was founded, this property was a mandatory resting site for thirsty travelers in northern Guanacaste, especially those using the *Camino del Arreo* route to trade cattle between Nicaragua and the Central Valley of Costa Rica. The battle that defeated the troops of William Walker in 1856 added to its historical luster, and the fragments of dry forest scattered across its pastures were seen in mid-20th century as a natural sanctuary, and the seed for what is now the Conservation Area of Guanacaste (ACG).

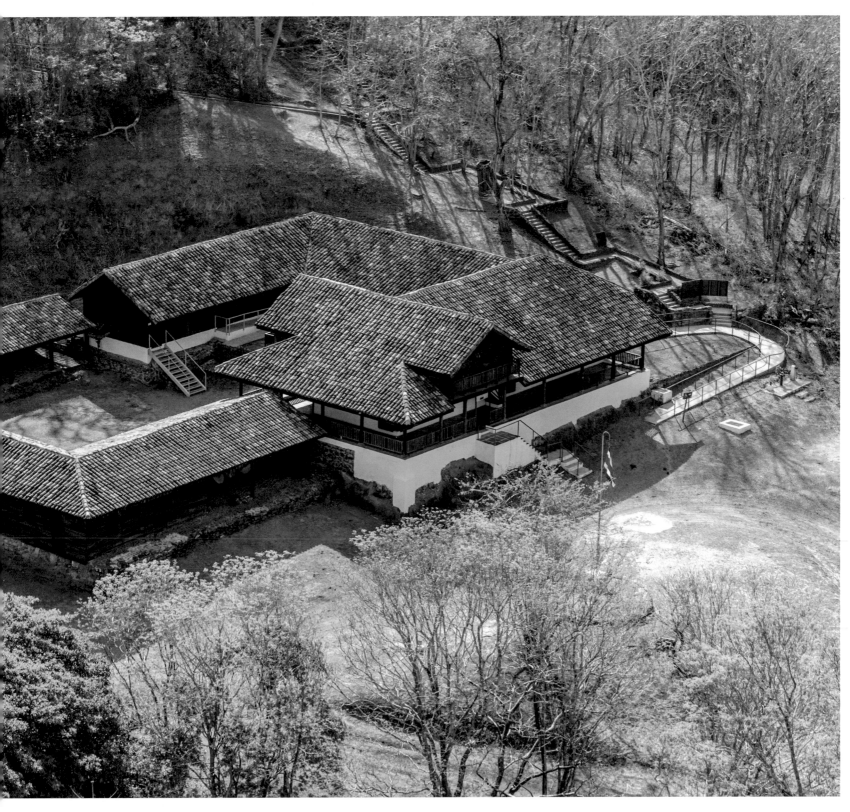

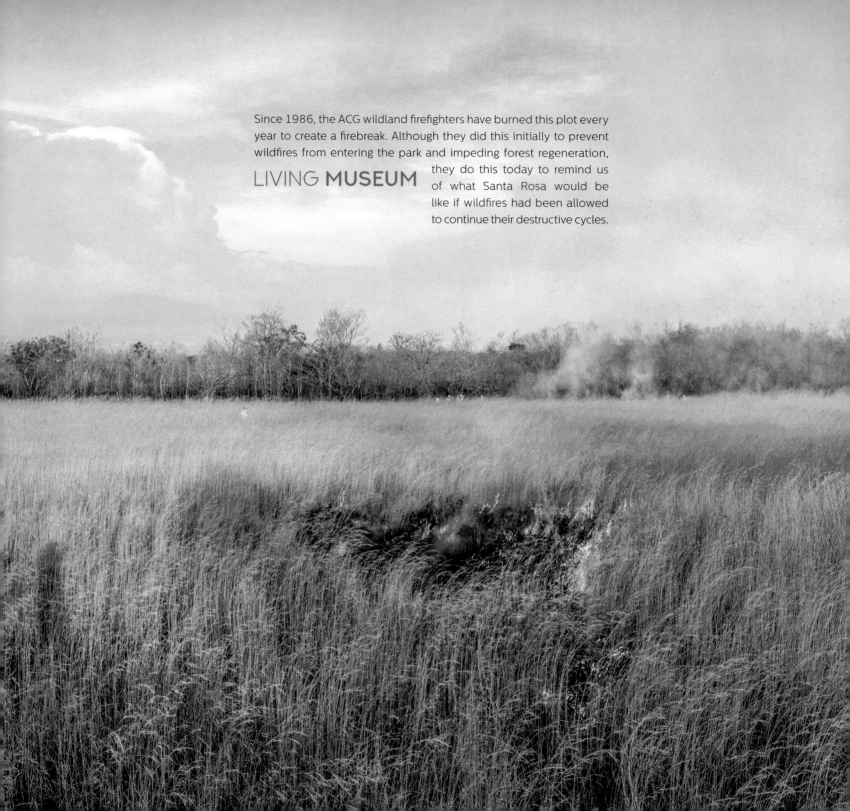

Since 1986, the ACG wildland firefighters have burned this plot every year to create a firebreak. Although they did this initially to prevent wildfires from entering the park and impeding forest regeneration, they do this today to remind us of what Santa Rosa would be like if wildfires had been allowed to continue their destructive cycles.

LIVING **MUSEUM**

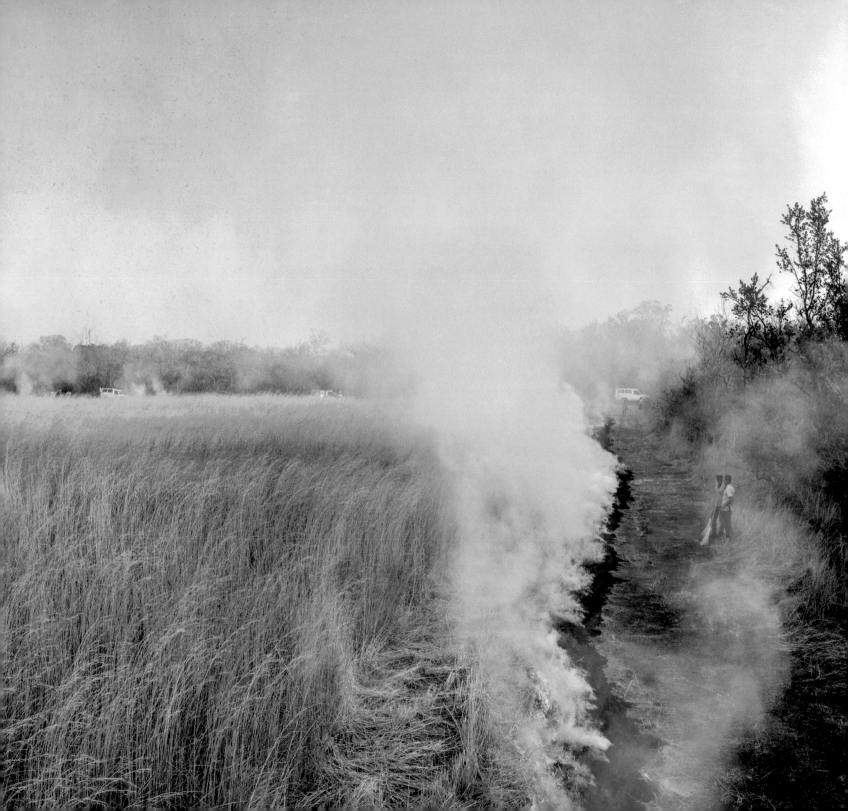

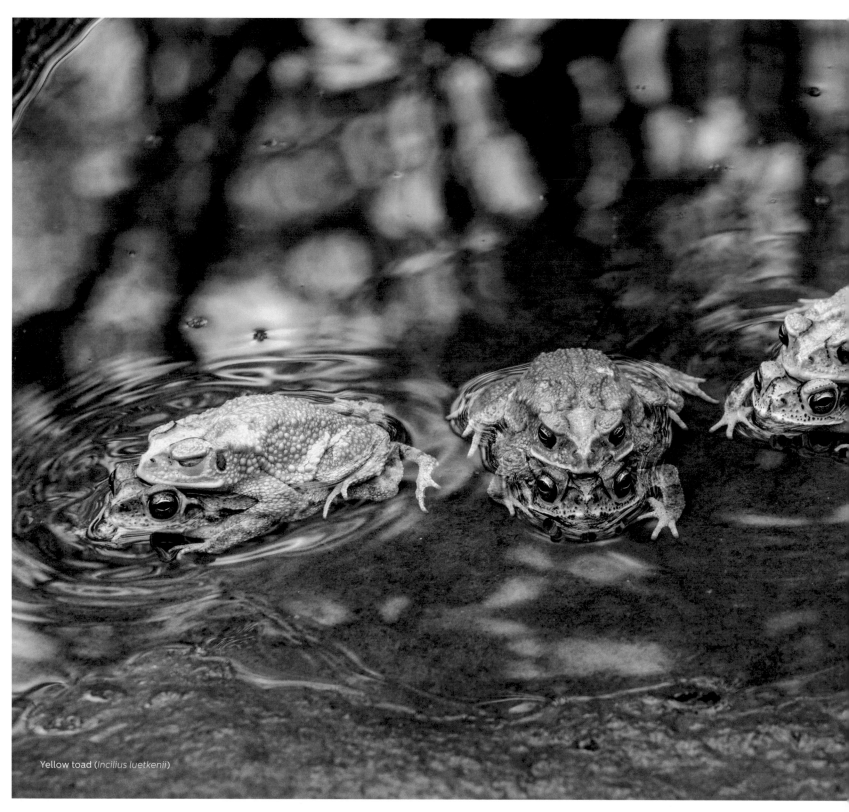

Yellow toad (*Incilius luetkenii*)

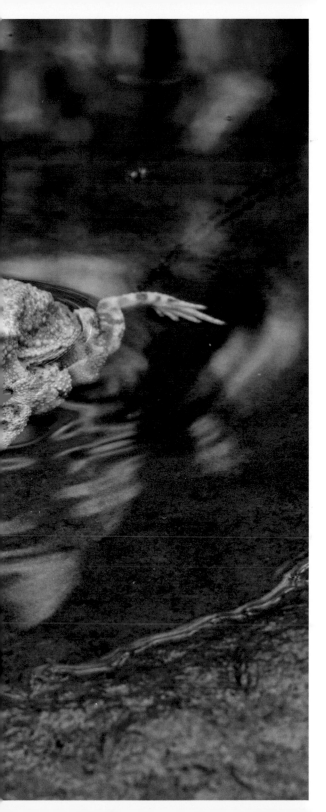

WATERHOLES

At the end of dry season, the few waterholes that remain in the park are the only places where animals can quench their thirst. But the pools that form after the first May rains serve another purpose; for a short period, about a week, the normally drab male yellow toad dons bright colors to attract females. Seemingly, the entire forest congregates around the fresh rainwater to celebrate the start of a new cycle.

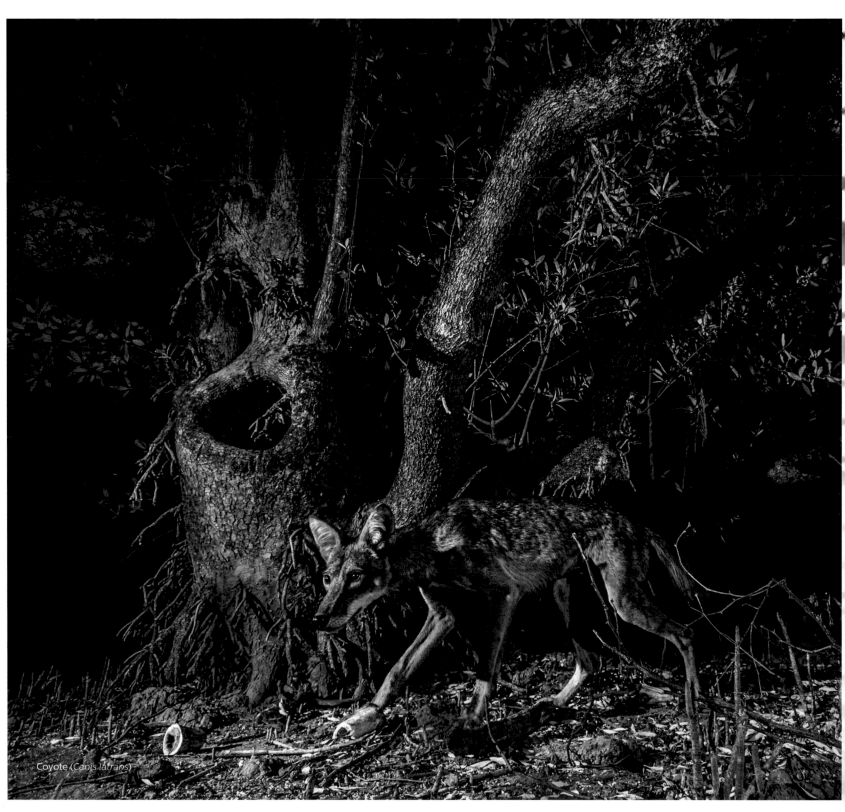

Coyote (Canis latrans)

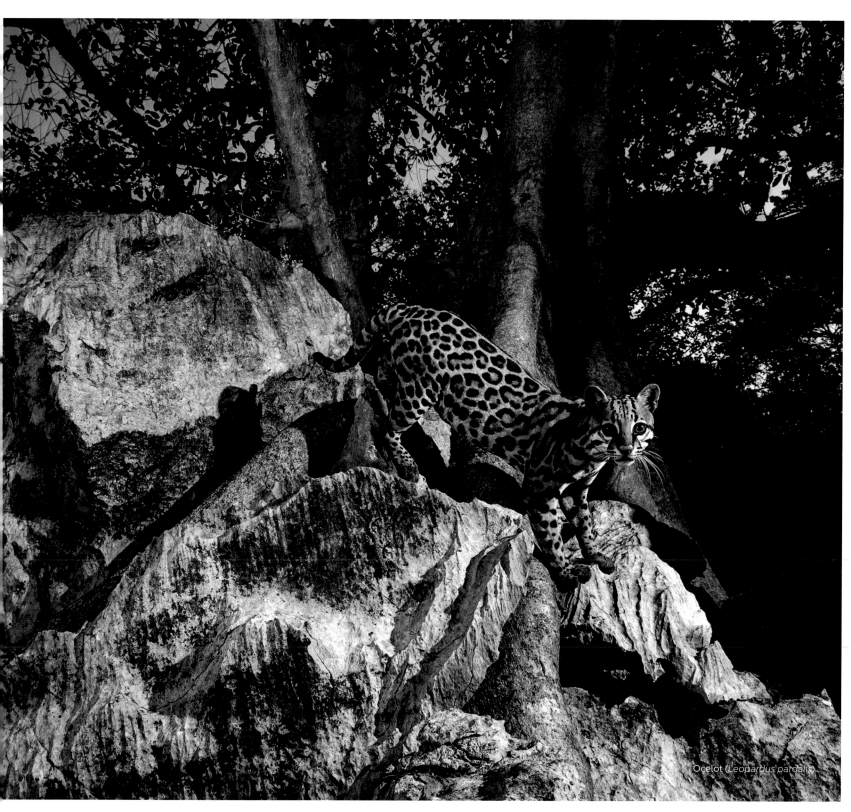

Ocelot (*Leopardus pardalis*)

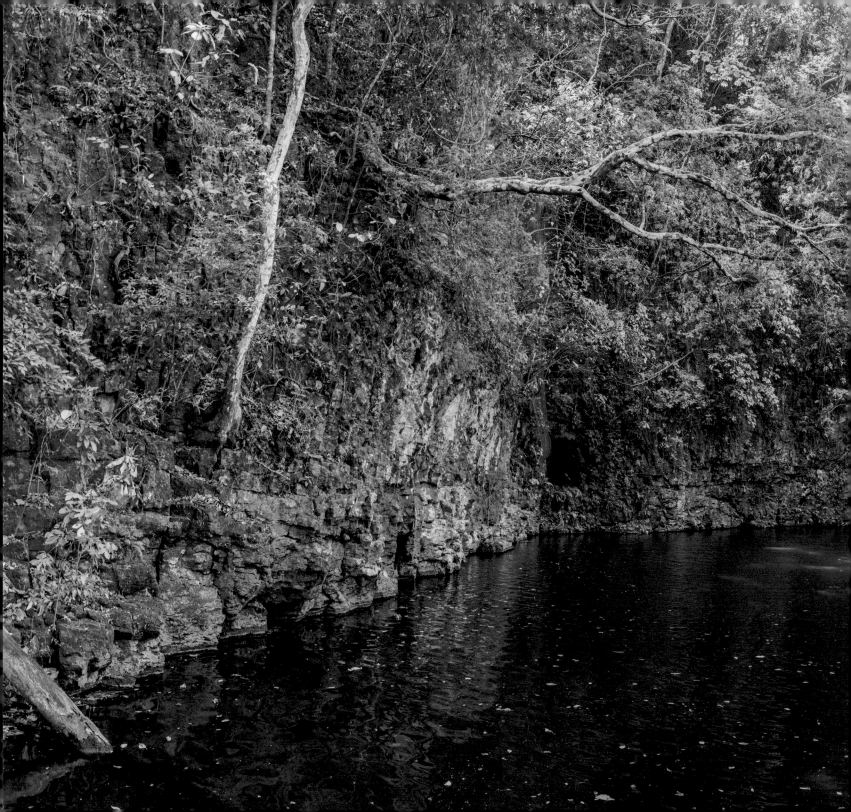

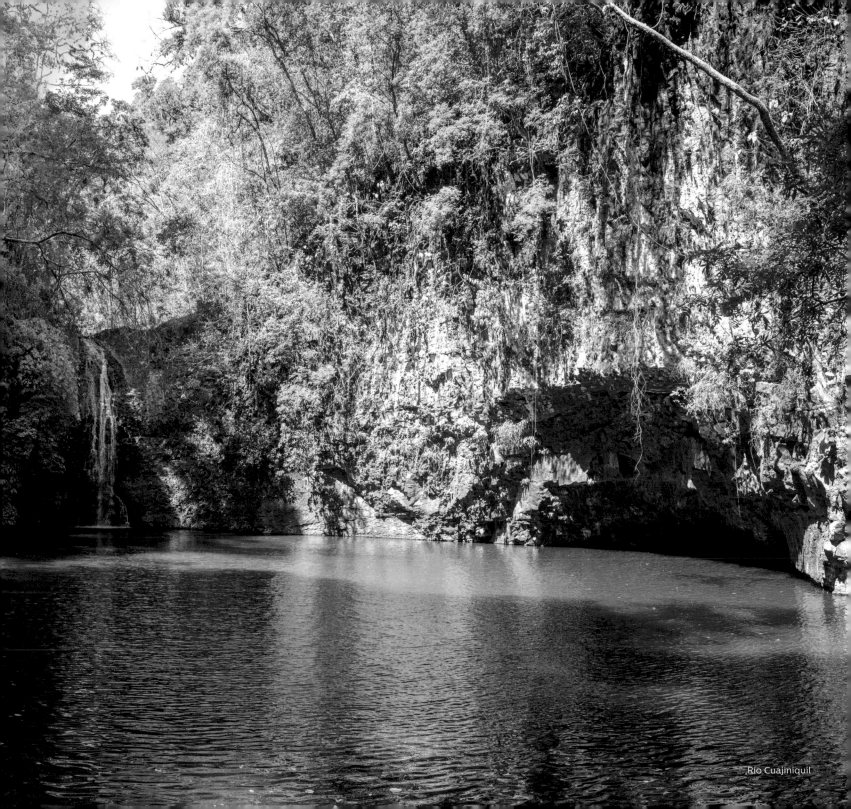

Río Cuajiniquil

THE LAND OF THE JAGUAR

As fierce as it is, the summer sun does not succeed in evaporating the water flow from all rivers in the dry forest. For example, on the Cuajiniquil (previous page) pools and even small waterfalls continue to flow in its lower basin. In areas such as these, less accessible to humans, large predators like the jaguar live their lives unperturbed.

Twenty years of camera trap studies and footprint counts in the ACG show that the population of this feline species has recovered completely from the devastation caused by large-scale cattle ranching and deforestation in the 1970s, and today it is one of the healthiest populations in the country.

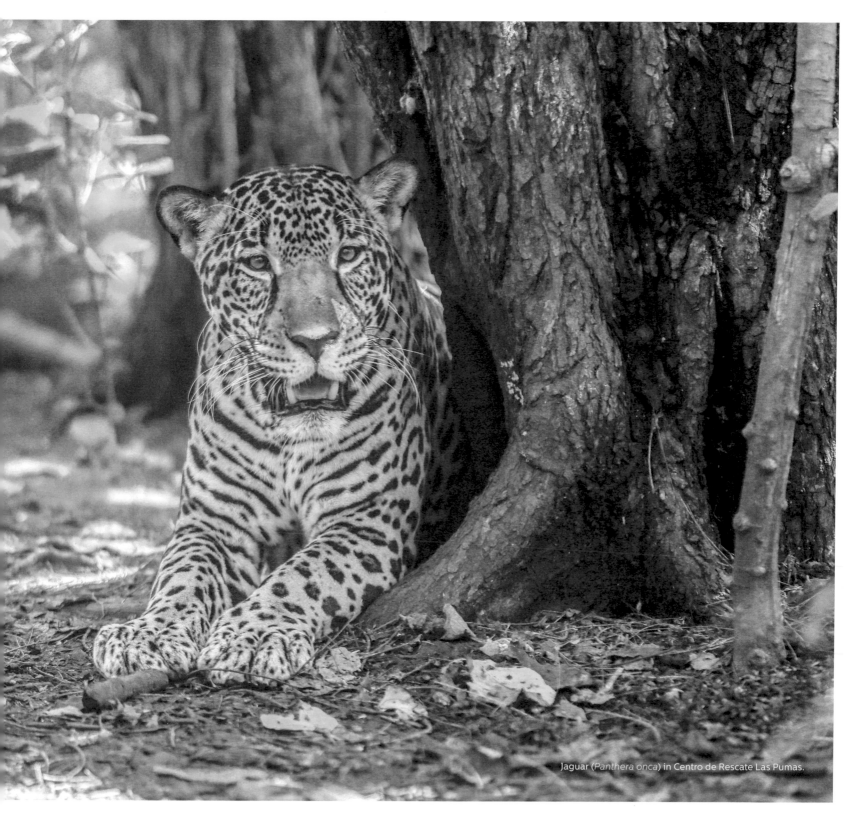

Jaguar (*Panthera onca*) in Centro de Rescate Las Pumas.

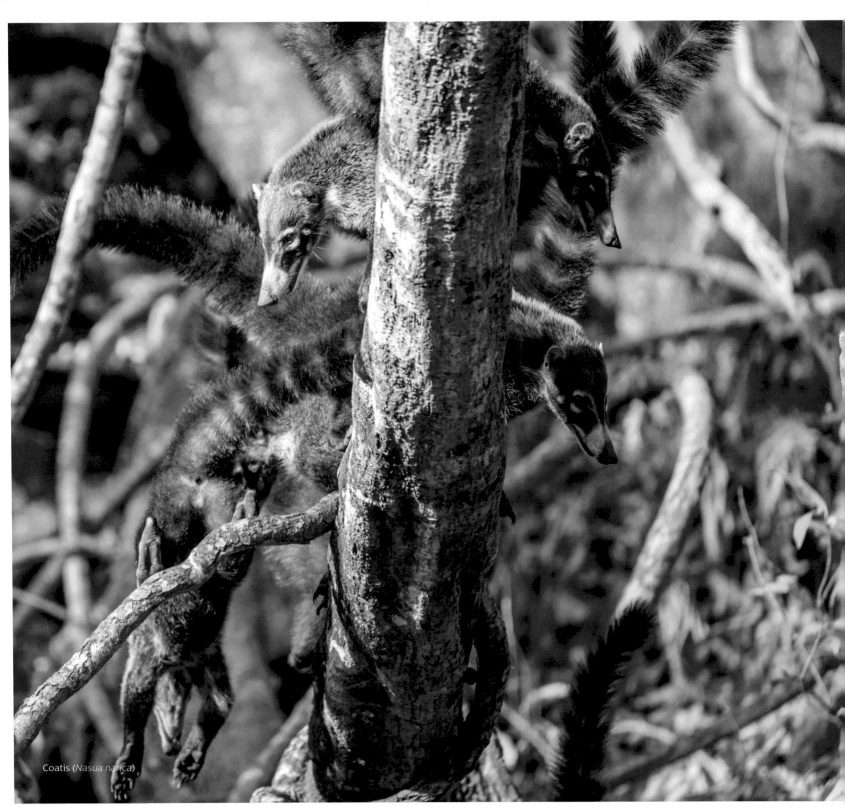

Coatis (*Nasua narica*)

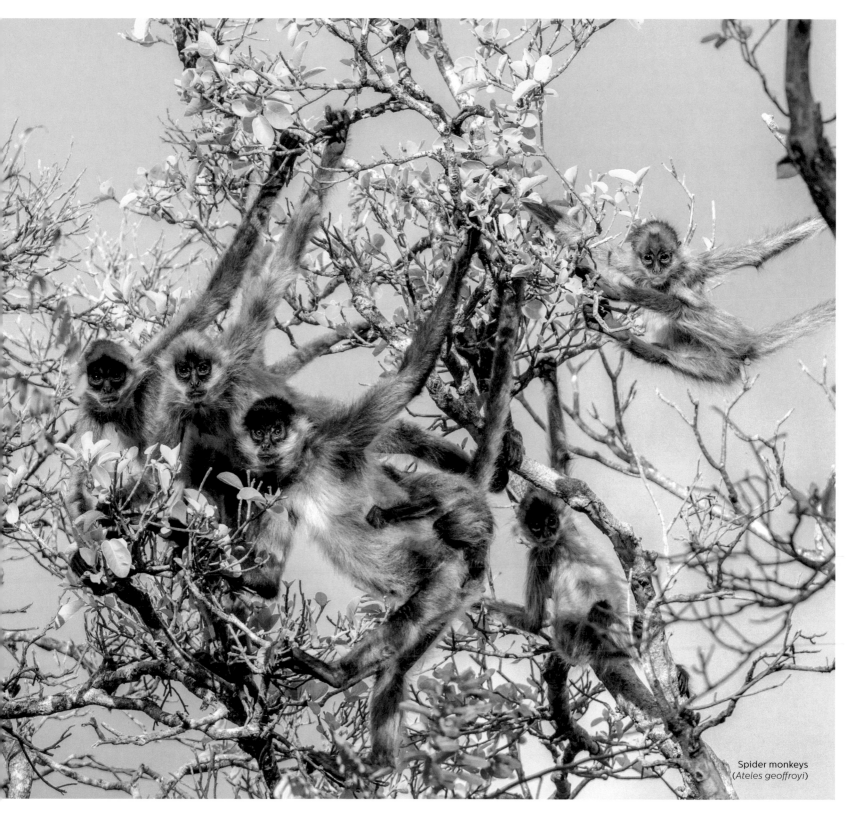

Spider monkeys
(*Ateles geoffroyi*)

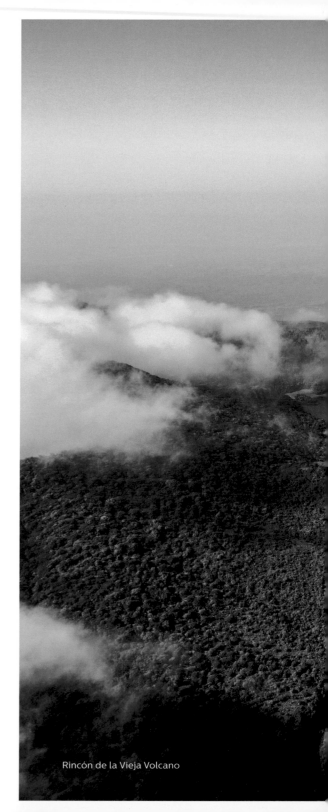

GREEN ESTATE

From the ocean floor to the tops of its volcanoes, the Conservation Area of Guanacaste (ACG) is the only park in the Americas that links up four of the main tropical ecosystems: coastal-marine, dry forest, cloud forest, and rainforest. This immense protected area also harbors four volcanoes: Orosí, Cacao, Santa María, and Rincón de la Vieja, of which only the last is active.

Rincón de la Vieja Volcano

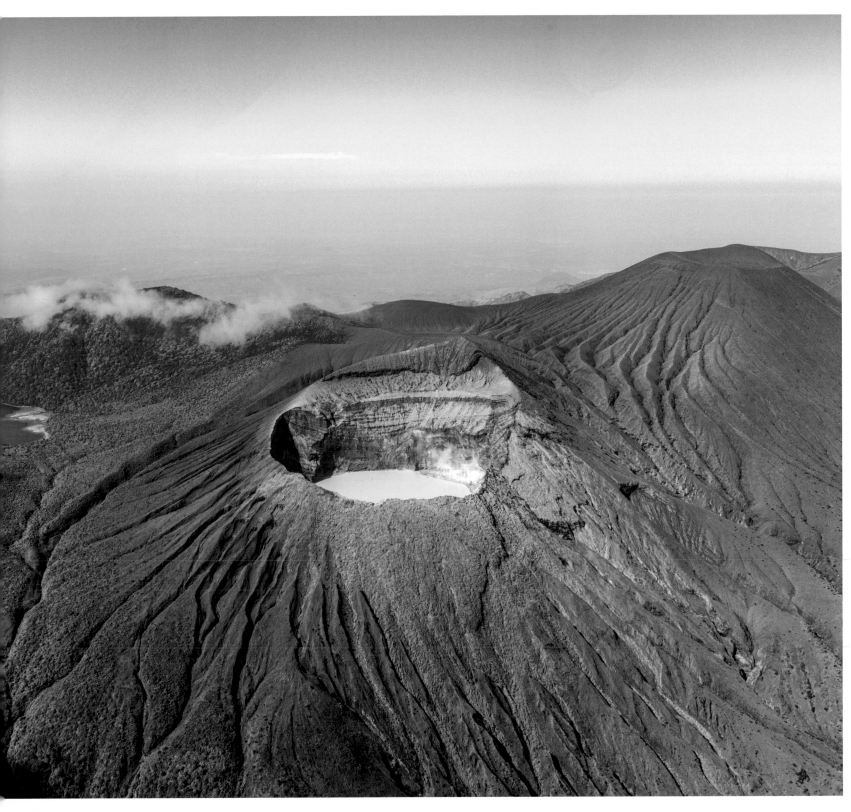

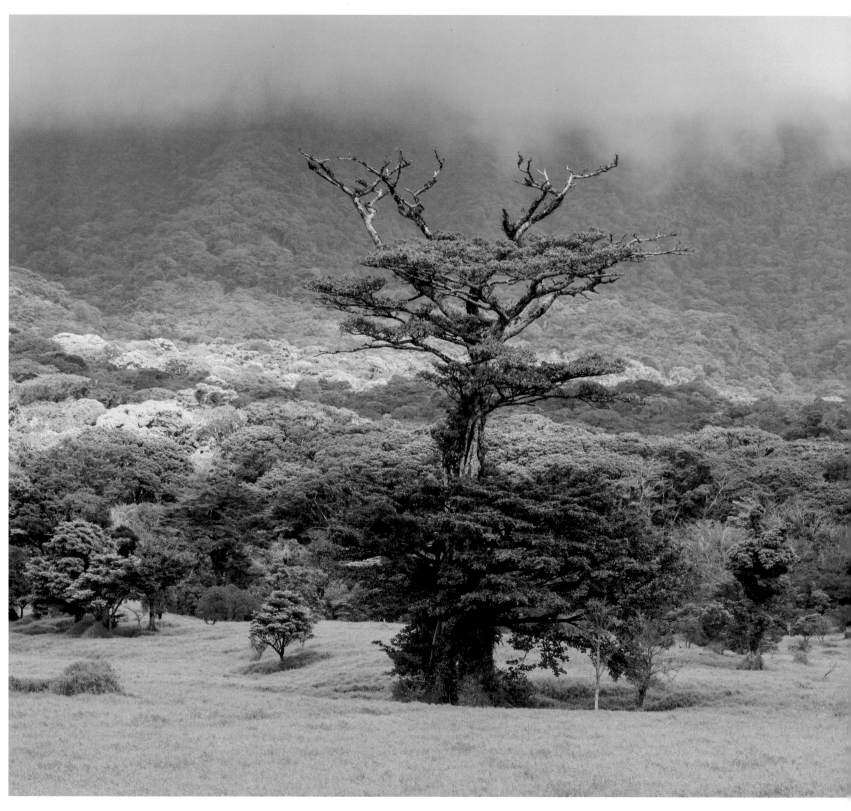

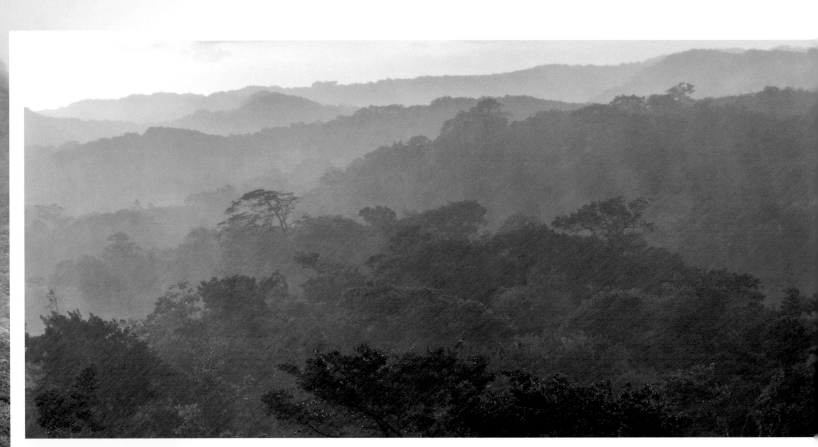

The great biological diversity that characterizes the ACG originates in large part from the variability in rainfall, which ranges from 47 inches (1200 mm) of annual precipitation in the dry forest to 138 inches (3500 mm) at the tops of the volcanoes and on the Caribbean slope of the park.

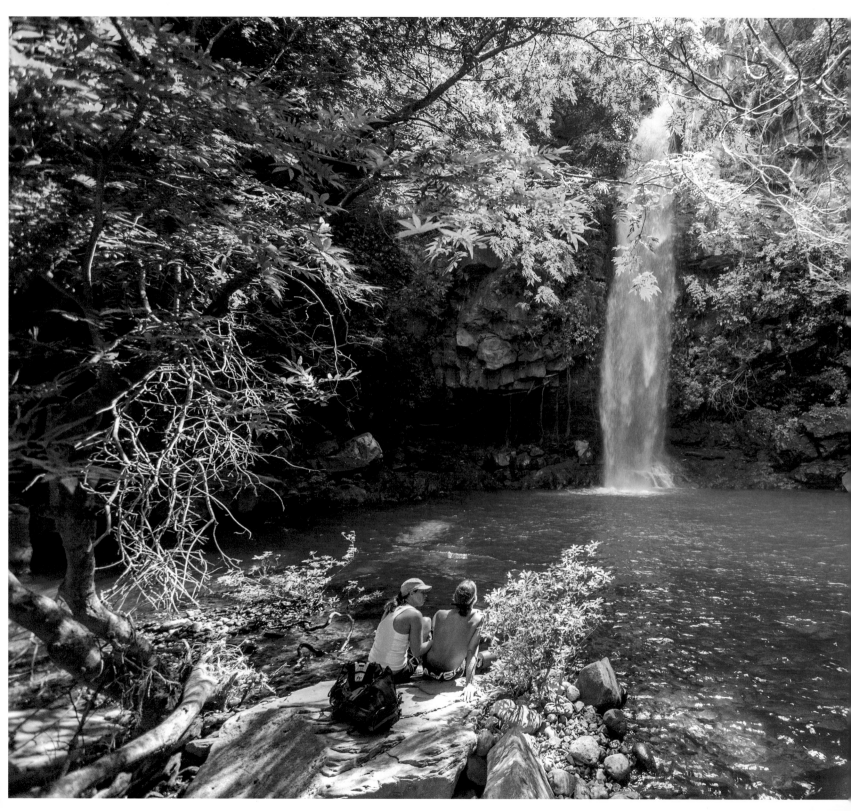

LA VIEJA

Just a short walk (3 miles / 5 km) from the entrance to Rincón de la Vieja, the turquoise waters of La Cangreja make it the most visited waterfall in the park.

Army ants (next page) don't make traditional nests, but at night they interweave themselves around their queen to form a protective ball. During the day, they move in orderly, incessant lines, a fierce, advancing army that captures insects and larvae and kills anything that stands in its way. Opportunistic flocks of birds follow the army ants closely, swooping down on the panicking insects that flee the army ants. Leaf-cutter ants cut leaves that they use as substrate for cultivating the fungi that they feed on.

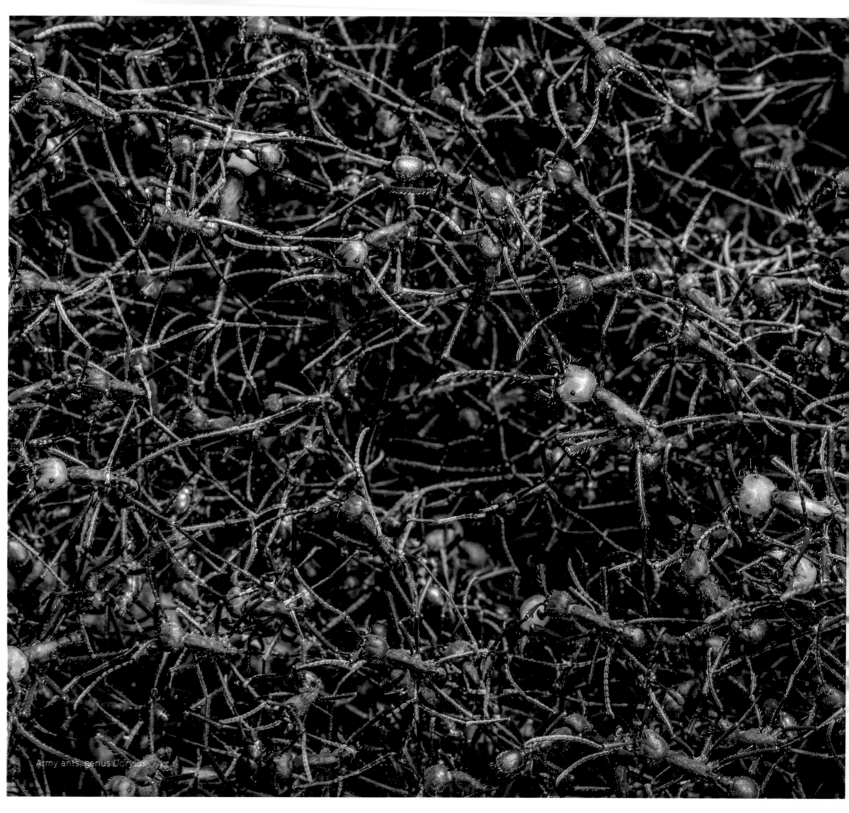

Army ants, genus Dorylus

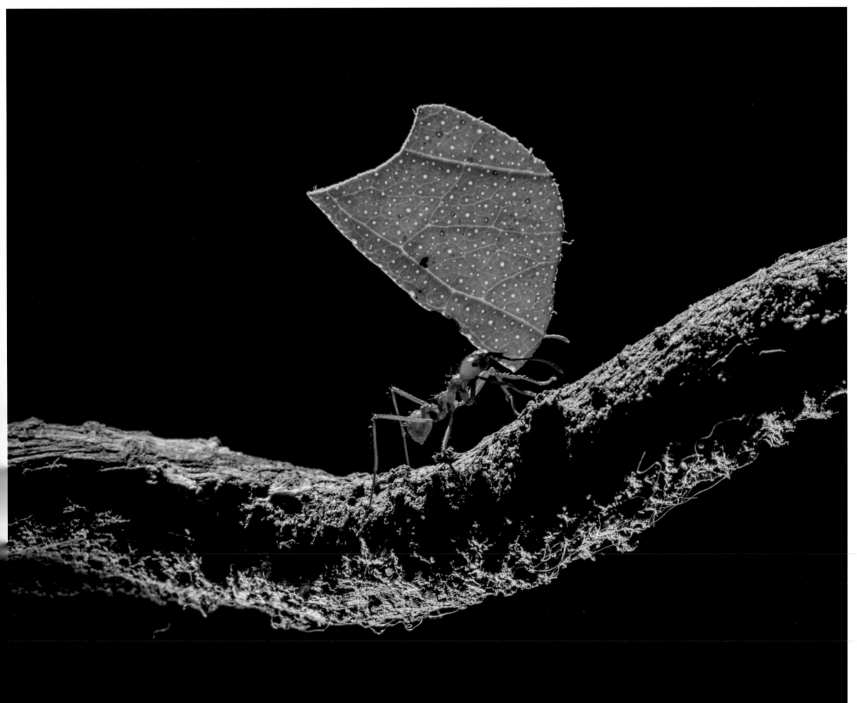

Leaf-cutter ant, genus *Atta*

OF
PAMPAS
& SAVANNAHS

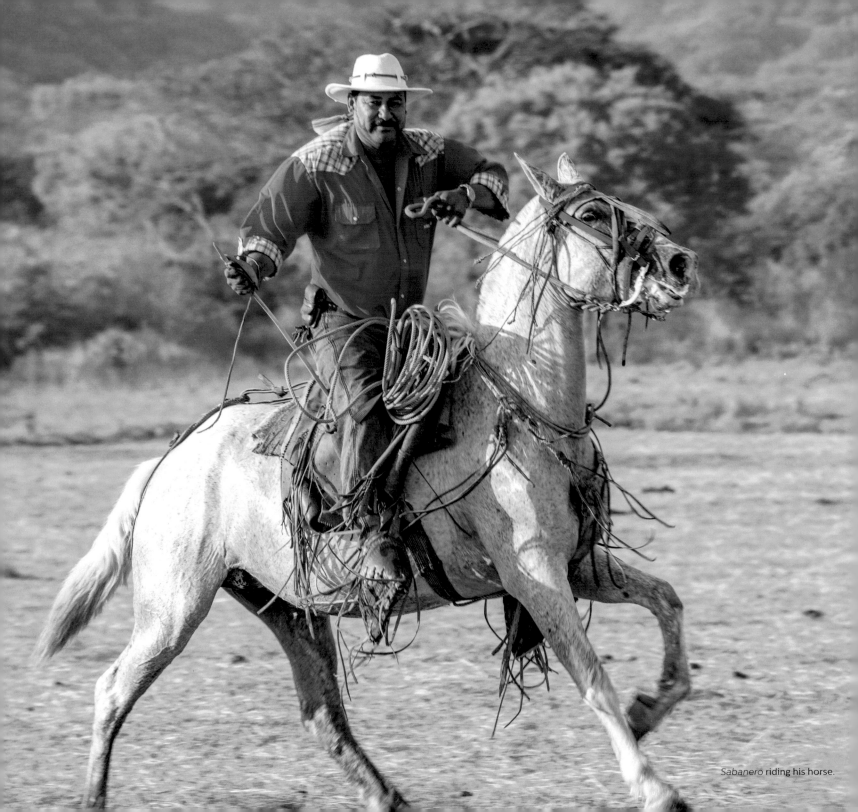

Sabanero riding his horse.

When conquistador Gil González Dávila arrived in the Gulf of Nicoya, in 1522, and set off on his first trek through the dense vegetation on the peninsula of the same name, he advanced largely bewitched by a delusion, one much more grandiose than the reality before him. He was convinced that he was on the verge of finding the *Estrecho Dudoso* (Doubtful Strait), a supposed maritime passage that connected the Pacific Ocean and the Caribbean Sea, which the nascent Spanish Empire had been in search of since the time of Columbus.

It was as though the shadow of the ambitious King Charles I fell over the conquistadors as they traipsed through Central America, reminding them of their mission but not distracting them from their *own* greed, for they knew that lavish honors would be showered upon whoever found such a passage, as it would be an invaluable means of consolidating the wealth and power of the Spanish crown.

If González Dávila wanted to find new navigation routes, he could not have reached a more ideal location, at least judging by the eye. Islands, mangroves, parallel channels, reefs, brackish marshes... the Gulf of Nicoya was a landscape defined by water. Dozens of tributaries emptied into both sides of the gulf, in that small sea enclosed by its shores. Standing beneath the open sky, the sight of the mouth of the Río Tempisque fusing with the currents of the Gulf of Nicoya must have fed the illusions of González Dávila and his troops that they were close to discovering the nonexistent strait.

On setting foot in Guanacaste, the Europeans discovered that the party had begun without them, long before their arrival. The Nicoya Peninsula and contiguous lands to the north, a region archeologists have labeled the *Gran Nicoya*, is an *entrepôt* where treasures—among them ceramics and jade—had accumulated for more than a thousand years. The peninsula was on trade routes established in ancient history that received waves of people migrating from north and south who left a rich tapestry of objects, hierarchical social structures, fashions, gods, music, languages, and culinary traditions.

Perhaps for Dávila and his pilot, Andrés Niño, it would have seemed implausible, but when they crossed Nicoya, the Chorotegas people had already lived in this region—and dominated it—for a thousand years, and they were not alone, for they shared it with other ethnic groups like the Nicarao, the Sutiaba (or Maribio), and the Tacacho.

The Chorotegas migrants had turned the Gulf of Papagayo into a scene of boisterous commercial trade, where Olmec, Maya, and Teotihuacan merchants exchanged precious products like jade and obsidian, deer hides, and quetzal feathers. Long before the Spanish conquest, Bahía Culebra (Snake Bay) had become one of the most populated places on the western coast.

Although neither the Gulf of Nicoya nor the Río Tempisque itself led to any other sea, nor to Lake Nicaragua, located 62 miles (100 km) northwest, the conquistadors were not mistaken in having judged the importance of the place, as they used it as a staging ground for forays into other regions of the country, and this spelled the beginning of the end for the peoples of the *Gran Nicoya*.

The Spanish incursions into Guanacaste spread through the province new implements of work, worship, art, and war: plows, crosses, guitars, and swords. All

of these elements foreshadowed the transformation of the economy, folklore, and idiosyncrasies of the local people, and forever planted the twin pillars of its landscape: cows and parishes.

Each natural barrier, each slope, each rivulet prefigures the history of a region. In Guanacaste, no other such phenomenon so defines a sense of place as does the mighty Tempisque, sometimes referred to grandiloquently as the Nile of Guanacaste. It is a physical barrier between the peninsula and the continental shelf, and on its 95-mile (150-km) journey it carries off water from the land and also supplies it with the nutrients needed for forests and agriculture.

As always, water is key for human survival, and here the rivers and springs make possible the cultivation of corn, a crop integral to the region and one that defines the local culinary traditions.

There are countless dishes in Guanacaste made from corn, among them farmer's cheese, curd cheese, *cacaos, pinoles, pipianes, chanfainas*, and Spanish plum sweets, dishes so unique to the region that there is no name for them in English. And you cannot talk about corn without also mentioning the *fogones* or wood stoves still found in many *campesino* homes, whose pitch-filled fragrance wafts from yard to yard.

Confined by the border with Nicaragua, the cantons of La Cruz and Liberia personify the harsh northern region of Guanacaste, cradle of the dry forest and large haciendas. It is the most arid part of the country and, not surprisingly, the most depopulated, yet the vitality of its cultural life, born from prehispanic migrations, sustains some of the most colorful aspects of national identity, as expressed in its music, food, festivals, and spiritual life.

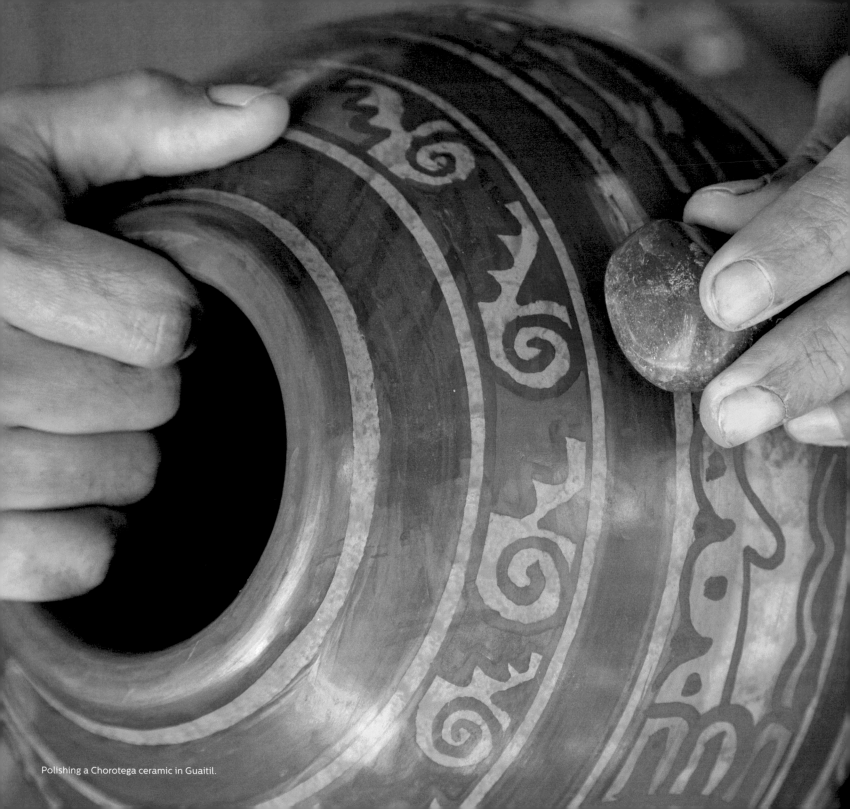

Polishing a Chorotega ceramic in Guaitil.

In the *pampa*, as the lowlands are popularly known, rise clouds of dust from which emerge the stereotype of the *sabanero*, the Costa Rican cowboy of colonial origins who, once a year, would round up, brand, and vaccinate the cattle raised semi-wild on the immense estates. His skills as a rider and his ability to lasso and subdue livestock without dismounting would form the ideal image of masculinity, and be celebrated in oral traditions, popular literature, and, of course, music.

In the 18th and 19th centuries, cattle ranching was concentrated on the plains along the eastern banks of the Tempisque, near the *Camino Real* or *Camino del Arreo*, the legendary route used to move cattle between Rivas, Nicaragua, and the central region of Costa Rica.

The Spanish colonial system of the *encomienda*, in which indigenous people were essentially treated as serfs, and the enslavement of black people, despicable in every way, did populate the universe of the large cattle ranches and the Nicoya villas and made the local culture even more diverse, composed as it was of whites, creoles, *zambos*, mulattoes, *mestizos*, and *pardos*. All aspects of life were transformed by the process of *mestizaje*, without which there would be no bullrings or *cimarronas* (musical parades), marimbas or *quijongos* (a string instrument), coyol wine (made from palm trees), "*bombas*" or *retahílas* (two forms of oral rhymed public performance).

The music performed at bullfights evolved through a syncretic process, in which the Hispanic rhythms and instruments that accompanied the bullfights fell under the influence of old indigenous ballads and instruments, and the result was marimba music, which adapted new themes to the old meter.

The extraordinary longevity of people living in five cantons in the Nicoya region led to it being designated as one of only four "blue zones" in the world.

For more than a decade people have ventured hypotheses about the particular social and environmental conditions that favor extreme aging. A relaxed lifestyle, centered around small family lands for growing one's own food, daily contact with friends and family, and a healthy environment, formed of diverse ecosystems, are all cited as contributing factors.

The first parish in the country was built in the city of Nicoya, the cultural center of the peninsula, in 1544. However deep the influence of the colonial past on today's customs, the canton continues to be transformed by real estate development and by the arrival of all kinds of travelers and modern explorers.

The current intensity of tourist traffic is something that all Guanacaste communities experience, perhaps a fitting inheritance for a region whose identity, for 2000 years, was formed by the many people who arrived here.

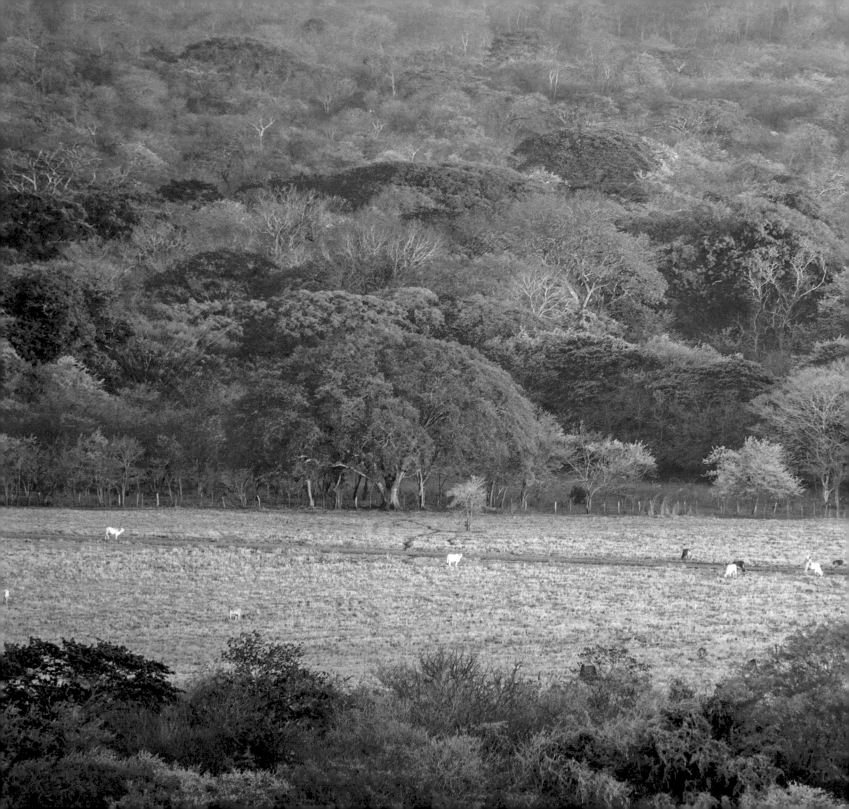

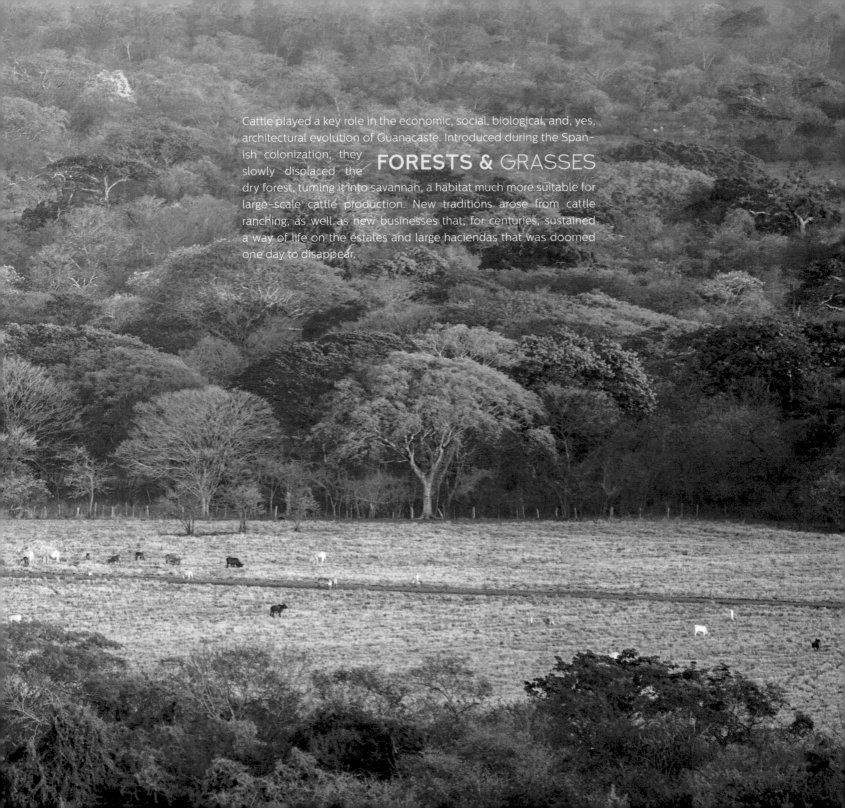

Cattle played a key role in the economic, social, biological, and, yes, architectural evolution of Guanacaste. Introduced during the Spanish colonization, they **FORESTS & GRASSES** slowly displaced the dry forest, turning it into savannah, a habitat much more suitable for large-scale cattle production. New traditions arose from cattle ranching, as well as new businesses that, for centuries, sustained a way of life on the estates and large haciendas that was doomed one day to disappear.

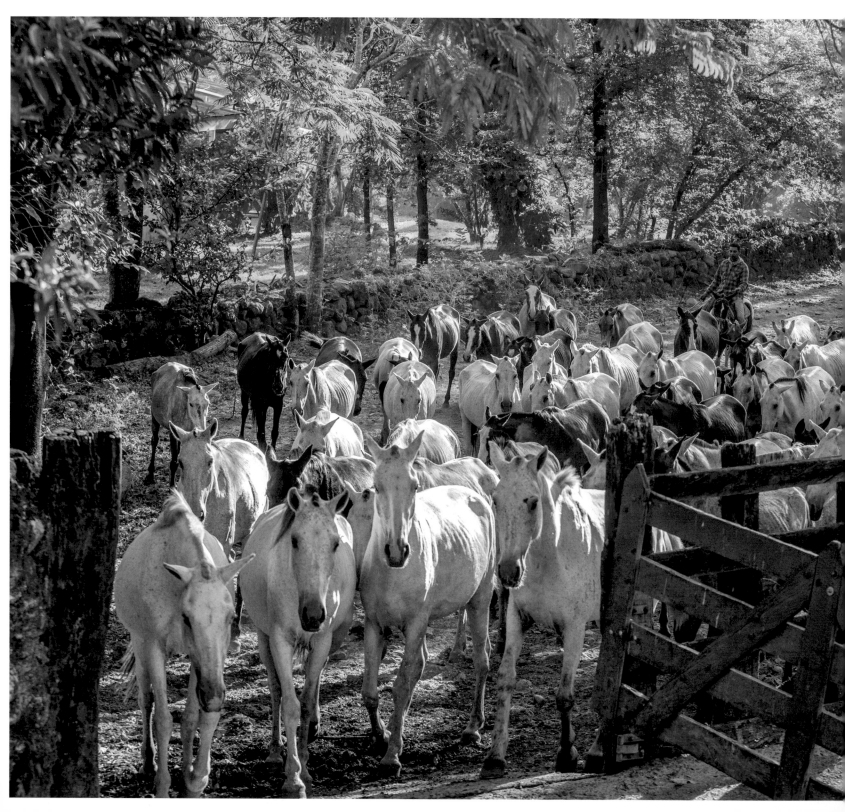

LARGE
HACIENDAS

In the 1930s, large estates and concentrated power were the standard, with 14 landowners controlling more than 1.2 million acres (500,000 hectares), over half of the province of Guanacaste.

Though reduced in size, the large haciendas continue, in many cases still proudly displaying their original names. Horses are no longer raised to herd cattle but to rent to tourists for gallops along the beach.

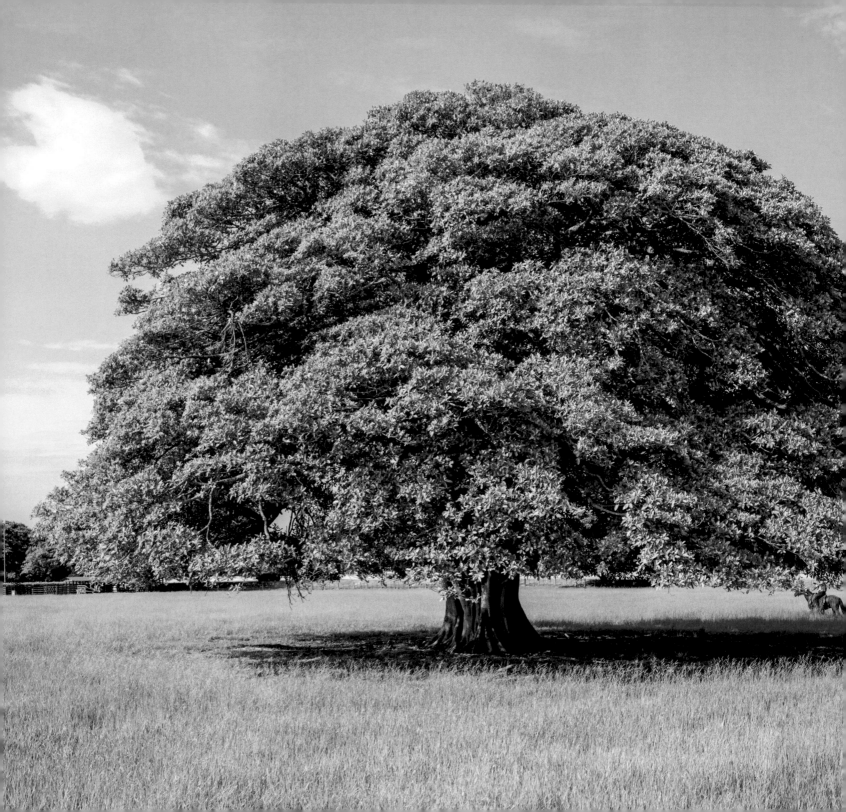

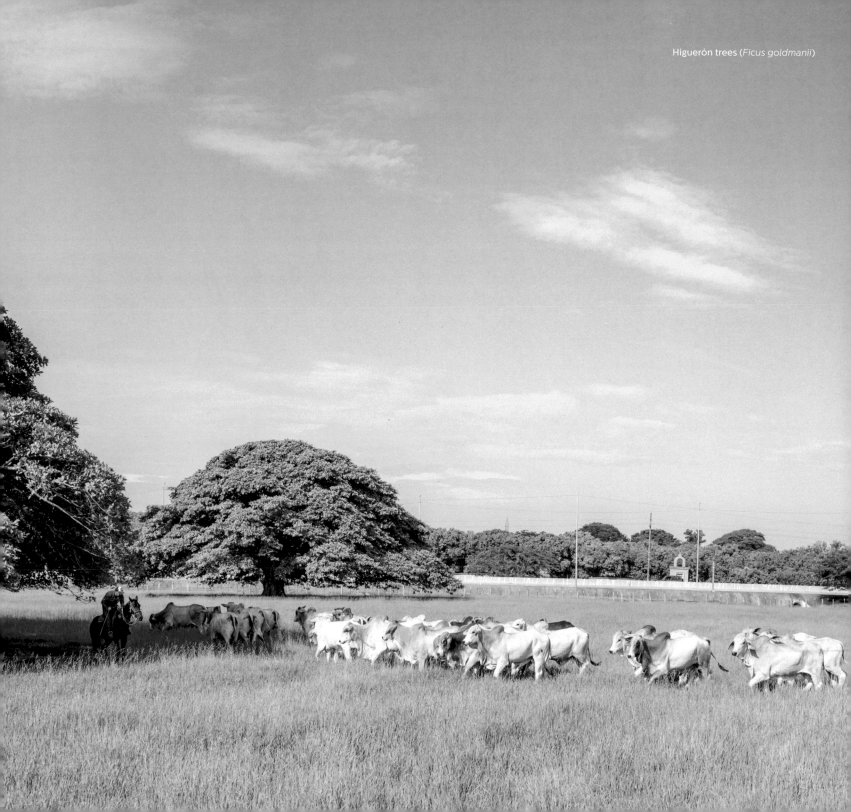

Higuerón trees (*Ficus goldmanii*)

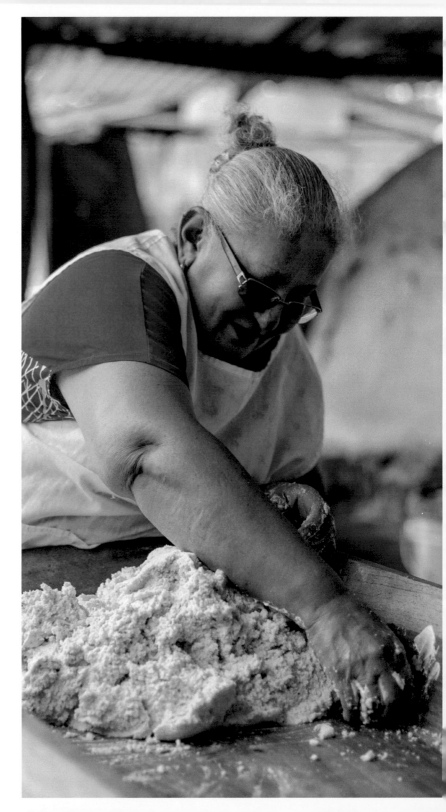

FESTIVALS AND
SAINTS

Every town has its saint and, in Guanacaste, every saint has a designated *fiesta*, or festival. From the beginning of the dry season until the first rains (November to May), popular "deities" take over the calendar and faith sweeps through the province, leaving a trail of *rosquillas* (savory baked corn snacks), bulls, marimbas, and games of chance. In small communities the festivities last three days, but in towns like Nicoya, Santa Cruz, and Liberia, they go on for a week.

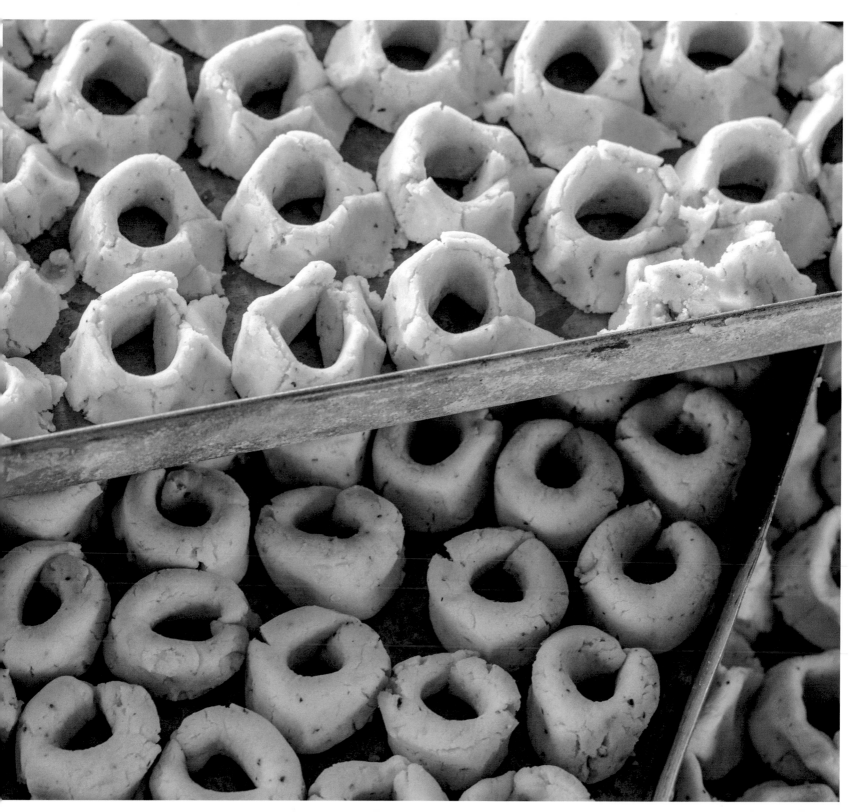

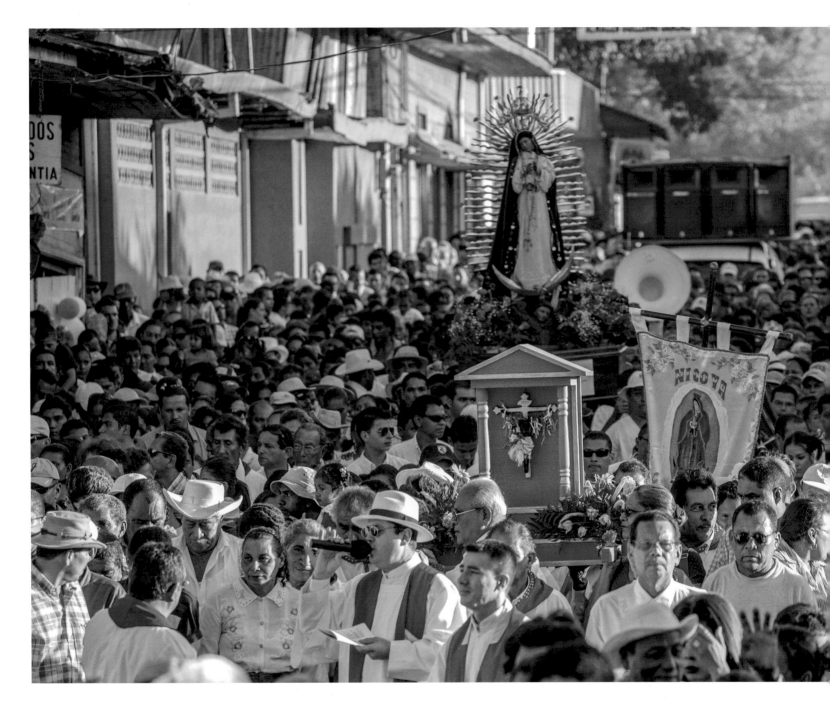

The *Santo Cristo de Esquipulas* heads the procession that kicks off the Santa Cruz *fiestas*.

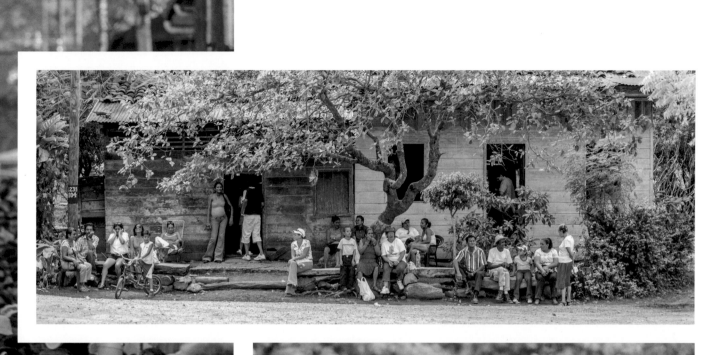

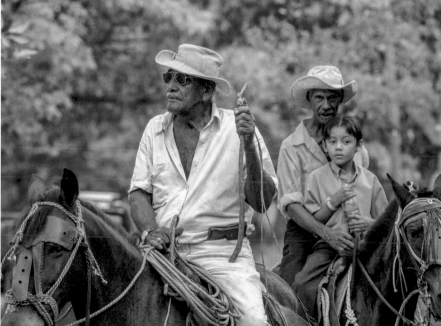

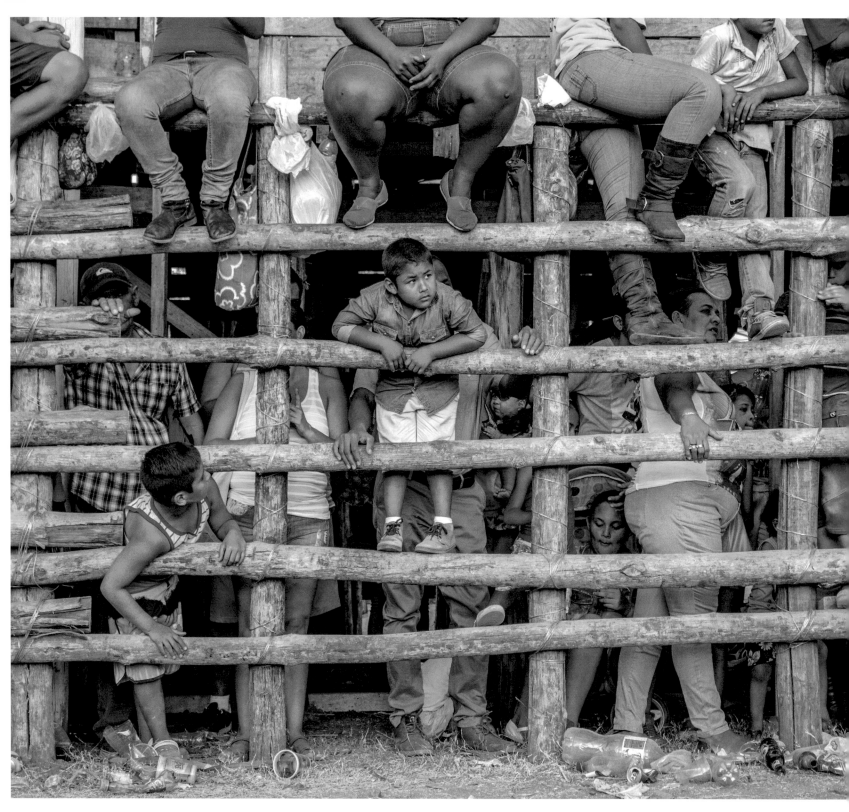

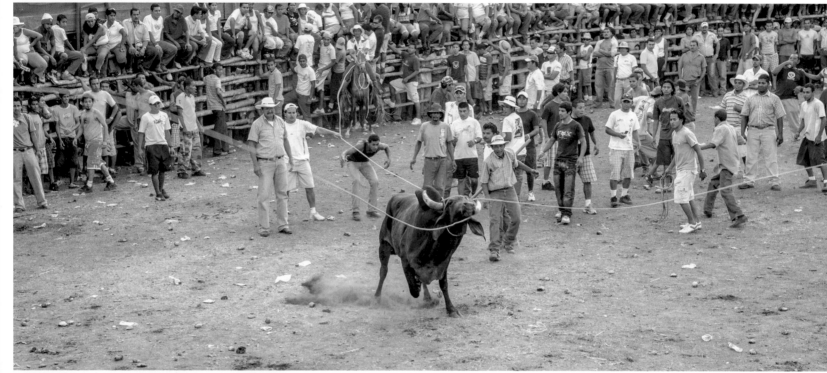

Bullfighting as practiced in Costa Rica and Spain differs in at least one very important way. Both cases are tests of masculinity, but the Guanacaste *sabanero* (cowboy) displays his fearlessness by dominating the animal with ropes and lassos, not with *banderillas* and swords. And the bull lives to fight another day.

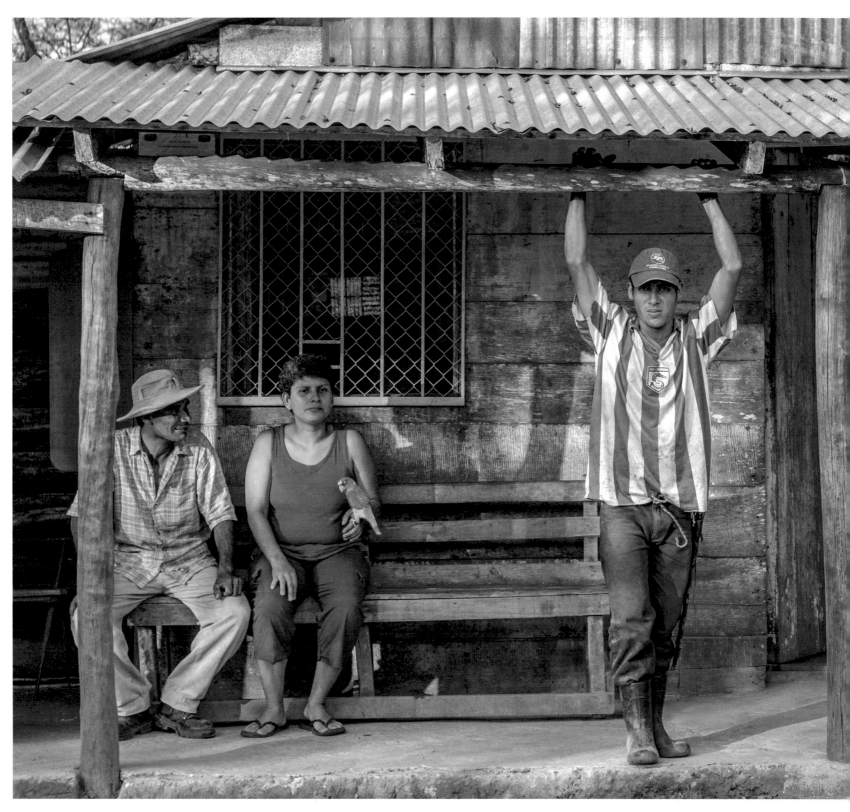

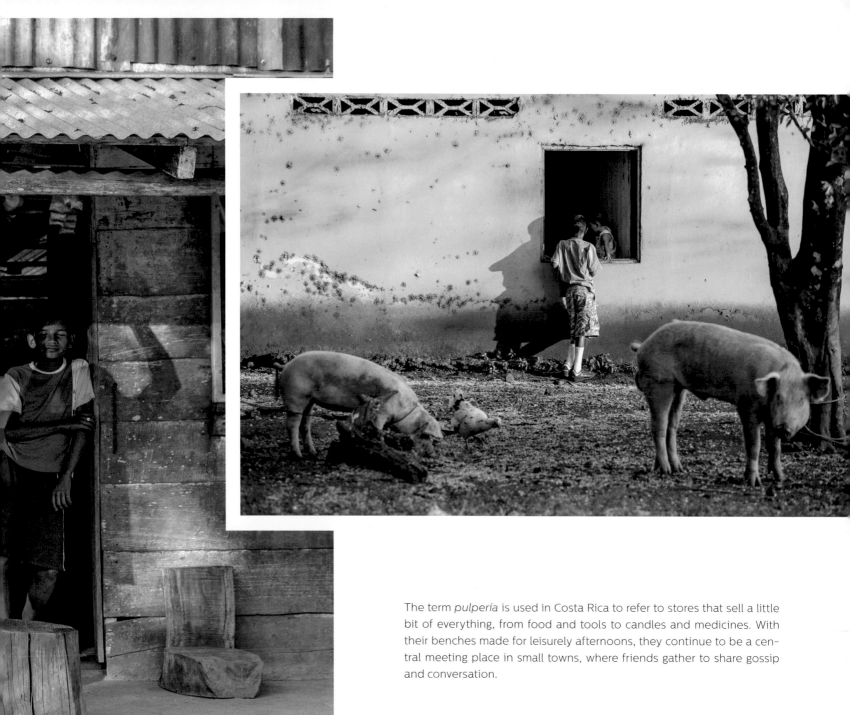

The term *pulpería* is used in Costa Rica to refer to stores that sell a little bit of everything, from food and tools to candles and medicines. With their benches made for leisurely afternoons, they continue to be a central meeting place in small towns, where friends gather to share gossip and conversation.

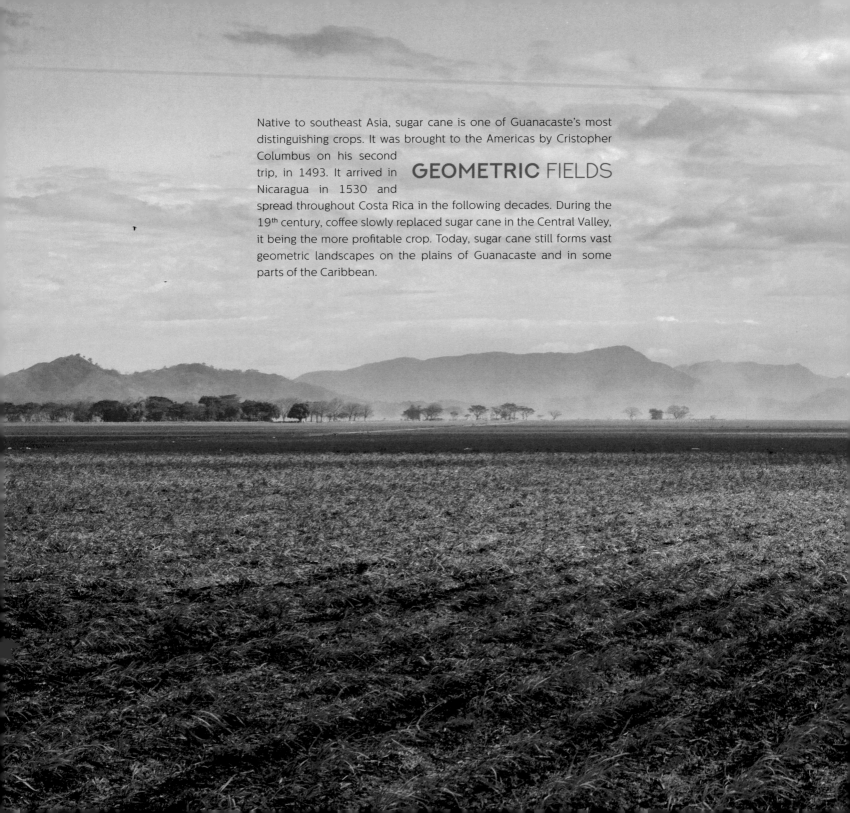

Native to southeast Asia, sugar cane is one of Guanacaste's most distinguishing crops. It was brought to the Americas by Cristopher Columbus on his second trip, in 1493. It arrived in

GEOMETRIC FIELDS

Nicaragua in 1530 and spread throughout Costa Rica in the following decades. During the 19th century, coffee slowly replaced sugar cane in the Central Valley, it being the more profitable crop. Today, sugar cane still forms vast geometric landscapes on the plains of Guanacaste and in some parts of the Caribbean.

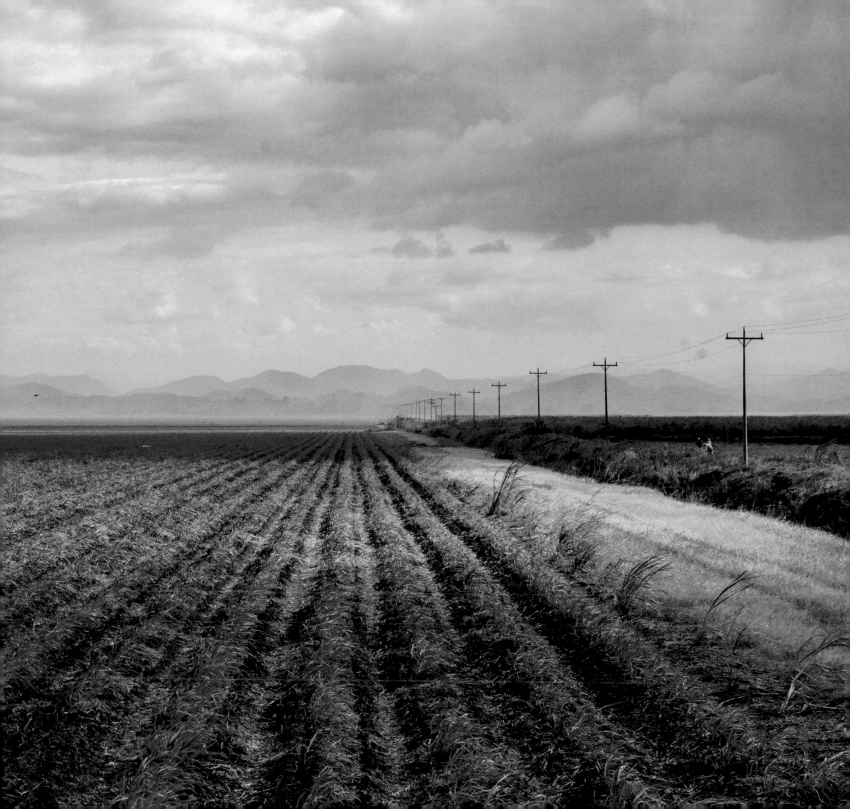

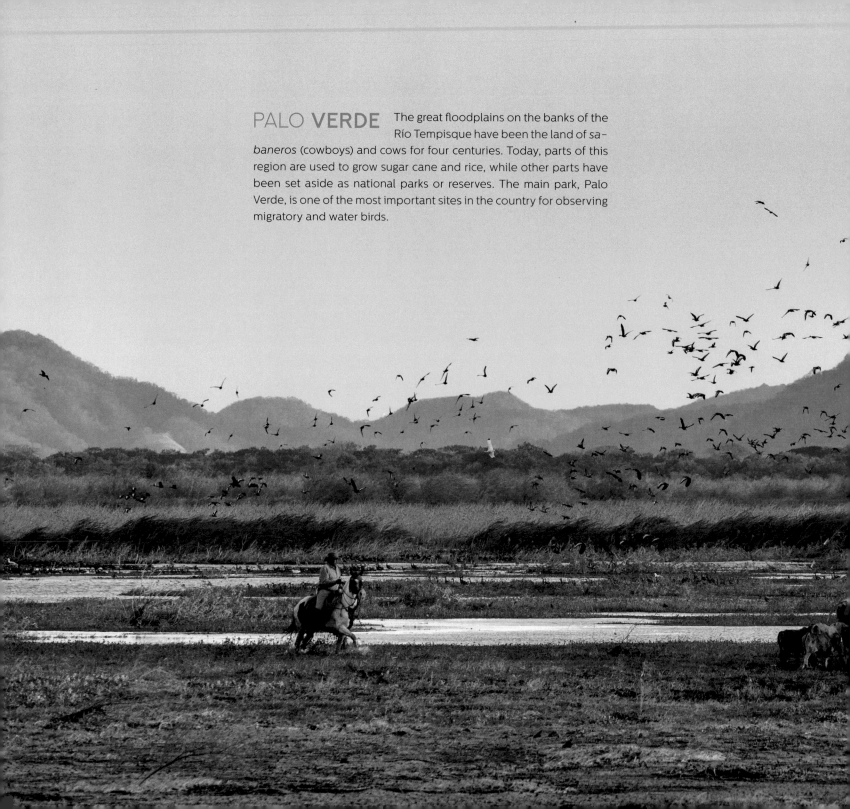

PALO VERDE The great floodplains on the banks of the Río Tempisque have been the land of *sabaneros* (cowboys) and cows for four centuries. Today, parts of this region are used to grow sugar cane and rice, while other parts have been set aside as national parks or reserves. The main park, Palo Verde, is one of the most important sites in the country for observing migratory and water birds.

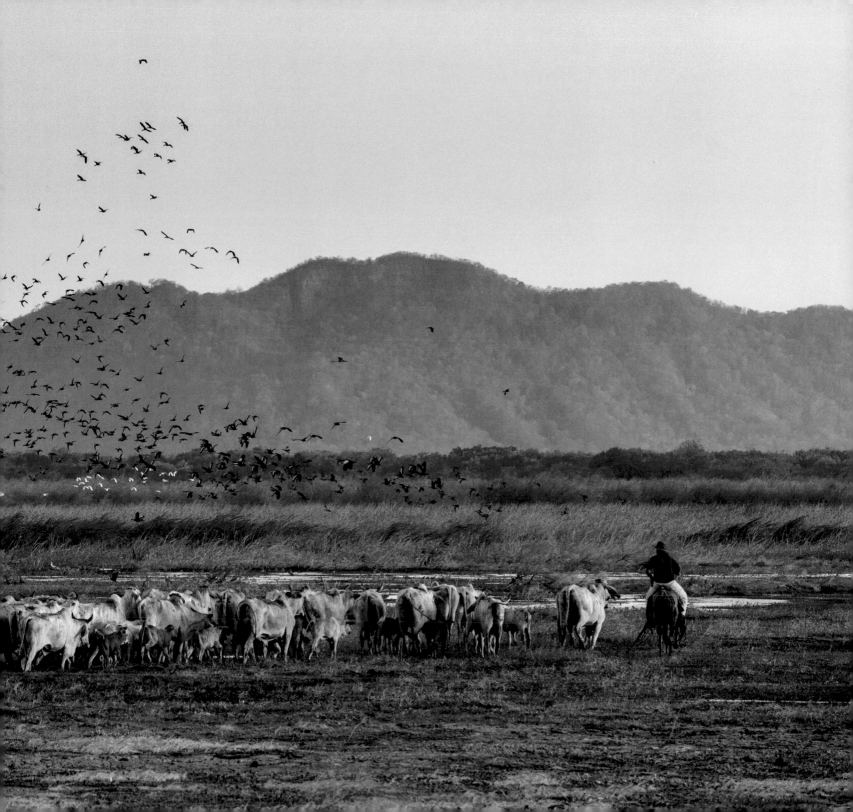

BIRDS AND
TOURISTS

Birdwatching is the tourist activity with the highest growth rate in the world and Costa Rica is a favored destination for bird lovers. Despite its tiny area, the country is home to 924 species of bird, 120 more than in all of North America. And the distances that need to be covered to visit different ecosystems are so short that in 2017 one Costa Rican birdwatcher was able to observe a record 357 species in just 24 hours.

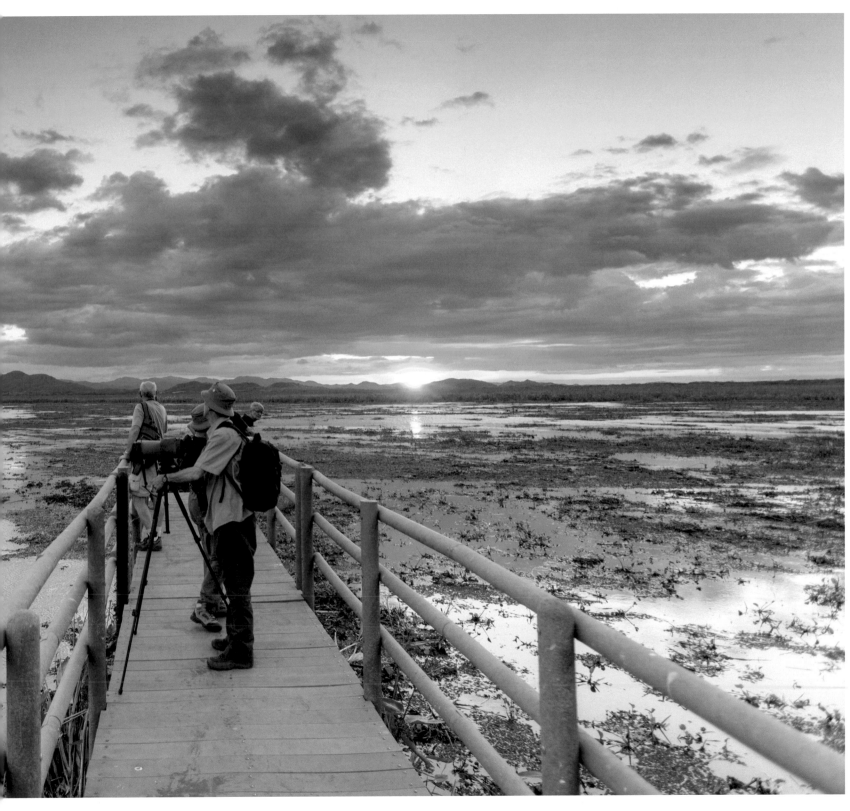

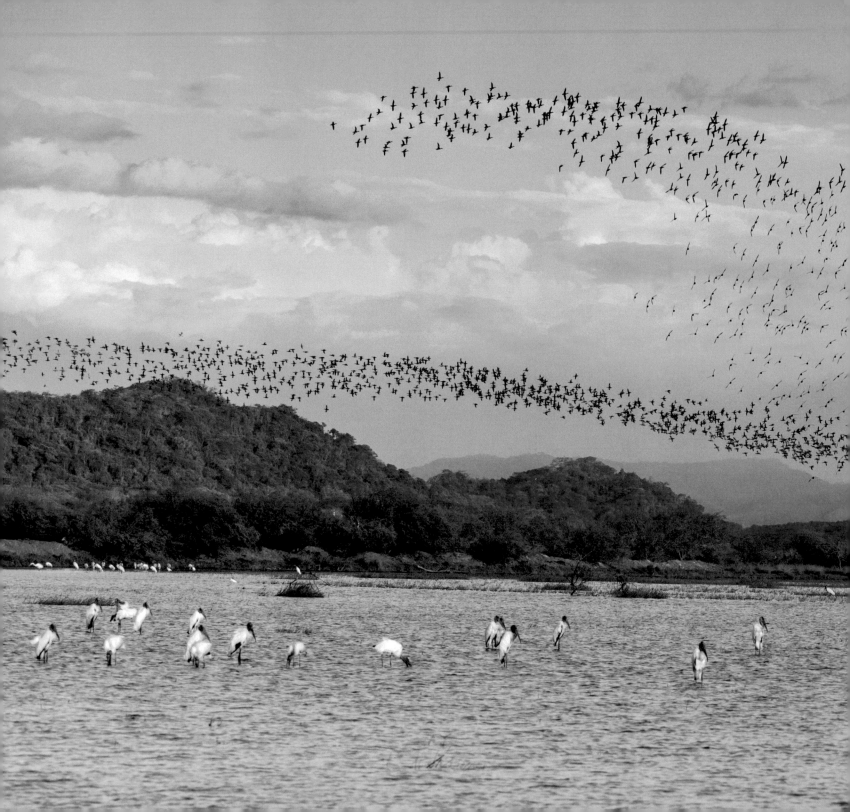

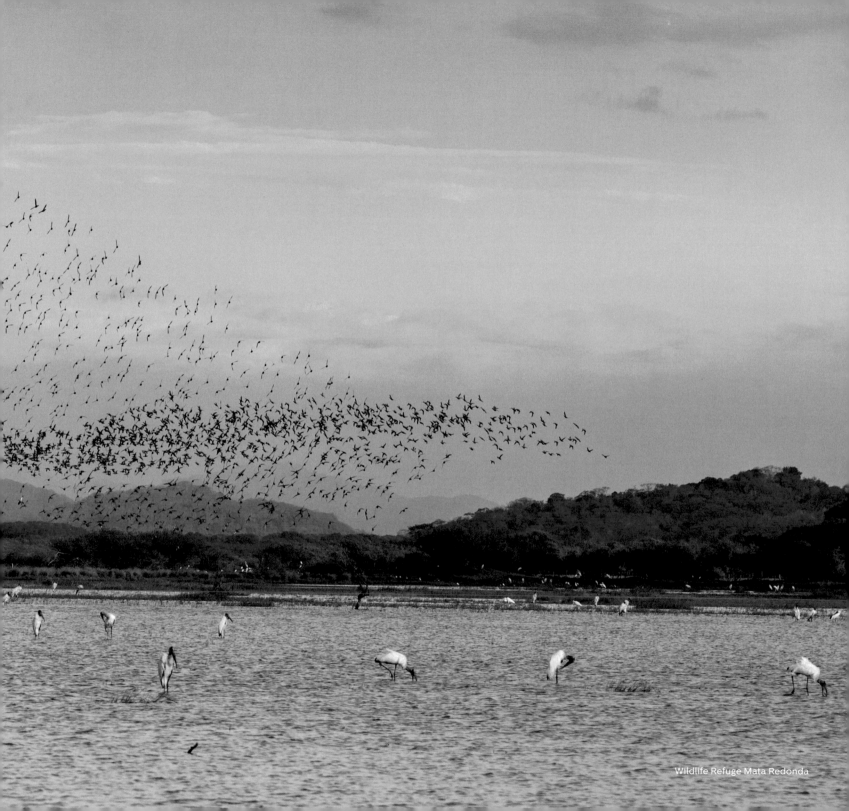

Wildlife Refuge Mata Redonda

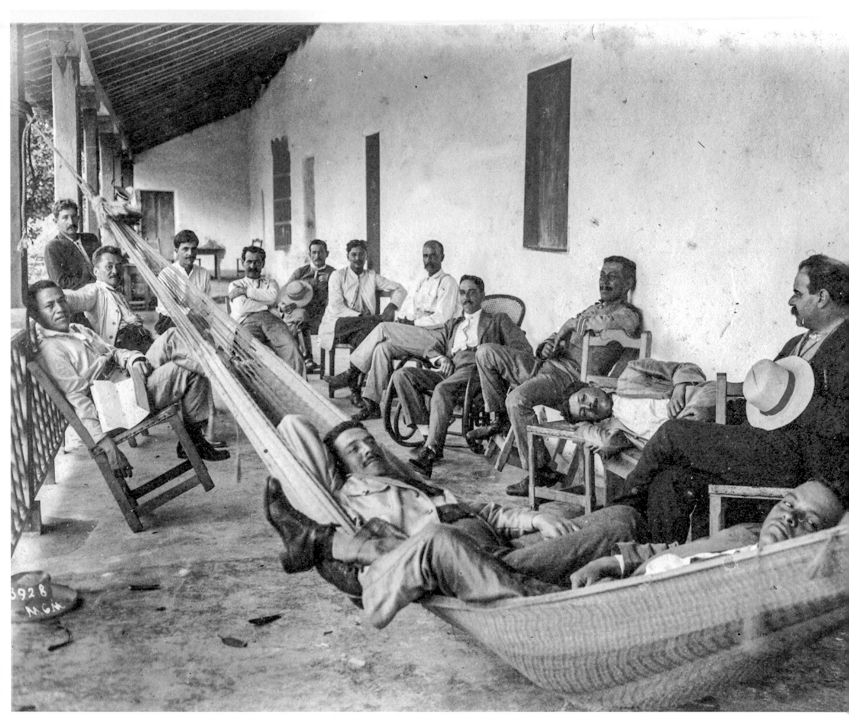

President Alfredo Gonzáles Flores tours Guanacaste in January, 1916.

INDEX

A
ACG — 41, 43, 45, 60, 62, 70, 74, 77
Alouatta palliata — 55
army ant — 79, 80
Ateles geoffroy — 73

B
Baird's tapir — 44
Bahía Culebra — 86
Bahía Salinas — 4
birdwatching — 110
blue zone — 89
bomba — 89
bullfighting — 103

C
Cabo Blanco — 5
Calocitta formosa — 52
Camino del Arreo — 60, 89
Canis latrans — 66
casona — 43
Cassia grandis — 4
cortez amarillo — 4, 18
Cebus capucinus — 12
Chiroxiphia linearis — 55
Chorotegas — 29, 86, 88
cimarrona — 89
coati — 72
Columbus — 85, 106
Conservation Area
 of Guanacaste — 41, 42, 43, 47, 60, 74
coyol wine — 89
coyote — 66

D
Doll Island — 59

E
encomienda — 89
Estrecho Dudoso — 85

F
Ficus goldmanii — 97
fogones — 87

G
genus *Atta* — 81

genus *Dorylus* — 80
Gran Nicoya — 86
green iguana — 7
González Dávila, Gil — 85
Gulf of Nicoya — 5, 85
Gulf of Santa Elena — 10
Gulf of Papagayo — 4, 86
Guanacaste — v, 3, 42, 45, 60, 86, 91, 95
guanacaste tree — 42
guanacastecos — 41

H
hacienda — 3, 41, 43, 60, 87, 93, 95
Hacienda Santa Rosa — 42
Hallwachs, Winnie — v, 45
higuerón tree — 97
Howler monkey — 55

I
Iguana iguana — 7
Incilius luetkenii — 64
Iran-Contra affair — 50
Isla Muñecos — 59
Islas Catalinas — 6

J
jaguar — 45, 71
Janzen, Daniel — v, 45
Junquillal Bay — 10, 59

K
King Charles I — 85

L
La Cangreja — 79
La Cruz — 87
Lake Nicaragua — 86
leaf-cutter ant — 79, 81
Leopardus pardalis — 67
Lepidochelys kempii — 25, 40
Liberia — 6, 87, 98
Lomas de Barbudal — 18
Long-tailed manakin — 55

M
mangrove forest — 23, 55
marimba — 89

marine turtle 49
Mata Redonda 113
Maya 86
Mesoamerican
 dry forest 42
Montezuma 35, 36
Mora, José Joaquín 43
Murciélago Islands 6

N Nasua narica 72
Nicaraguan Contras 50
Nicoya 89, 98
Nicoya Peninsula 5, 17, 35, 86
northern raccoon 13

O ocelot 67
Odocoileus virginianus 53
olive ridley 25, 40
Oliver North 50
Ollie's Point 50
Olmec 86

P Pachira quinata 15
Palo Verde 108
pampa 41, 42, 89
Panthera onca 71
Pan-American Highway 43
peccary 45
pink shower tree 4
pink trumpet tree 4
planned burns 45
Playa Avellanas 21
Playa Buena 15
Playa Buenavista 30
Playa Guiones 33
Playa Naranjo 49, 50, 55, 56
Playa Nosara 29
Playa Ocotal 8
Playa Ostional 25, 27
Playa Sámara 33, 35
Playas del Coco 6
pochote tree 15
Potrero Grande 50
Pre-Columbian times 45

Procyon lotor 13
pulpería 105
quijongo 89

R Río Cuajiniquil 69, 70
Río Tempisque 85, 86, 89, 108
Rincón de la Vieja
 Volcano 74, 79
rosquilla 98
rosy trumpet tree 4

S sabanero 41, 89, 103, 108
Santa Cruz 98
Santa Rosa 60, 62
Santa Rosa
 National Park 46
Santa Teresa 35
Santo Cristo
 de Esquipulas 100
savannah 93
spider monkey 73
sugar cane 106

T Tabebuia ochracea 4, 18
Tabebuia rosea 4
Tamarindo 2, 21
Tapirus bairdii 44
Tecoma impetiginosa 4
Teotihuacan 86
ticos 6, 43
tropical dry forest 42

U Upala 41

W Walker, William 43, 60
Witch's Rock 50
white-faced capuchin 12
white-tailed deer 53
white-throated
 magpie-jay 52

Y yellow toad 64, 65

CREDITS

PHOTOGRAPHERS

Unless indicated below, all photographs
are by Luciano Capelli.
Nick Hawkins: pp. 7, 22, 53, 55, 80, 81
José María Tijerino: pp. IV, 66, 67
Mauro Quirós: pp. 98, 99, 102
Adrian Hepburn: pp. 12, 88
Pepe Manzanilla: pp. 44, 71
James Kaiser: p. 23
Gregory Basco: p. 42

COVER PHOTOS

Luciano Capelli,
Pepe Manzanilla

LAYOUT DESIGN & PHOTO RETOUCHING

Francilena Carranza

LOGO, MAP & ILLUSTRATIONS

Elizabeth Argüello

ORIGINAL TEXT

María Montero,
Luciano Capelli

ENGLISH ADAPTATION

Noelia Solano,
John Kelley McCuen

TEXT REVIEW

John Kelley McCuen,
Stephanie Monterrosa

CONCEPT

Luciano Capelli,
Stephanie Monterrosa,
John Kelley McCuen

PRODUCTION

Luciano Capelli,
John Kelley McCuen

PRODUCTION ASSISTANT

Stephanie Monterrosa

ABOUT
THE
PUBLISHERS
—

Cornell University Press fosters a culture of broad and sustained inquiry through the publication of scholarship that is engaged, influential, and of lasting significance. Works published under its imprints reflect a commitment to excellence through rigorous evaluation, skillful editing, thoughtful design, strategic marketing, and global outreach. The Comstock Publishing Associates imprint features a distinguished program in the life sciences (including trade and scholarly books in ornithology, botany, entomology, herpetology, environmental studies, and natural history).

Ojalá publishes illustrated books about the biodiversity and cultural identity of Costa Rica. With every title, we strive to intertwine images and text to transport readers on a voyage through this extraordinary country.

Zona Tropical Press publishes nature field guides and photography books about Costa Rica and other tropical countries. It also produces a range of other products about the natural world, including posters, books for kids, and souvenirs.

COSTA RICA REGIONAL GUIDES

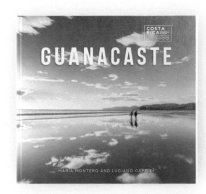

GUANACASTE

MARIA MONTERO AND LUCIANO CAPELLI

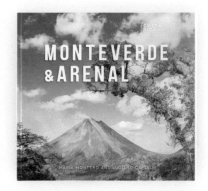

MONTEVERDE & ARENAL

MARIA MONTERO AND LUCIANO CAPELLI

CARIBBEAN COAST

YAZMIN ROSS AND LUCIANO CAPELLI

CENTRAL VALLEY

AVAILABLE IN 2020

MANUEL ANTONIO

AVAILABLE IN 2020

OSA & CORCOVADO

AVAILABLE IN 2020

Principal font: Centrale Sans